contents

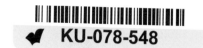

european painting from the 13th to the 15th century

The Gothic era opens a new chapter in the history of art, one which marks the transition from the earlier Middle Ages to the Renaissance and the beginning of secular painting. In contrast to the earlier Middle Ages, whose imagery was rooted entirely in the realms of the hereafter, the artists of the Gothic era looked to the present for their inspiration and thereby arrived at a new realism. Their discovery of a new, material world also led them to a more joyful vision of reality which placed greater emphasis upon feeling.

With the development of court society and the rise of civic culture, the Gothic style blossomed. Art was infused with a new sophistication and elegance. Loving attention to detail, animated use of line, a luminous palette and a masterly technique were typical features of the new style which would quickly take Europe by storm. Gothic art reached its high point in the frescos and panel paintings of Giotto, Duccio, the Lorenzetti brothers, Simone Martini and Fra Angelico in Florence and Siena, in stained glass in France, in the altarpieces of Jan van Eyck and Rogier van der Weyden in the Netherlands, in the exquisite illuminations executed by the Limburg brothers and other miniaturists, in the panels issuing from the courts of Prague and Vienna, and in the Soft Style of the North German masters and the graceful works of Stefan Lochner.

spread and characteristics of the gothic style

Gothic was originally a term of contempt. Only much later would it emerge as the name of an epoch. It was unknown to the masters of Gothic painting. It was coined by the Italian theoreticians of the 15th century – as a potent byword for something that needed to be quashed. Even Giorgio Vasari (1511–1574) traced the style explicitly back to the

Goths, in his eyes the most heinous of criminals imaginable. It was they, supposedly, who had razed the classical edifices of the Romans and killed their architects, and then filled all Italy with their accursed buildings. They brought with them a German order whose ornamentation and proportions differed drastically from those of classical antiquity. They were shunned by good artists as monstrous and barbaric. Theirs was a style which, even though it had swamped the world, was characterized not by measure and degree, but by confusion and chaos.

A more temperate opinion was not to be expected from Vasari, the 16th-century Florentine patriot. Although we are indebted to his biographies of famous artists of the Renaissance for their endless wealth of information, his errors of judgement continue to colour our thinking even today. In truth, there are such fundamental differences between Italy and the rest of western Europe that it is highly questionable whether Giotto (c. 1270–1337) and his followers – for Vasari the heralds of a rebirth of art in the spirit of antiquity – can be subsumed under the overall heading of "Gothic". Of the thousands of paintings which have survived from this period, it is clear in all but a handful of cases from which side of the Alps their artists came. Even the terms used to describe the different phases within the era are very different, with artistic developments in Italy still being known by their century – as Dugento or Duecento, Trecento and Quattrocento.

Leaving aside the phenomenon of the so-called International Gothic or International Style of c. 1400, which we shall be discussing later, the Gothic style never really took root in Italy. A hundred years later, artistic developments in the North and the South had diverged even further than before and around 1300. While the High Renaissance triumphed in the latter in the shape of Raphael (1483–1520) and Leonardo (1452–1519), the Late Gothic masters of Nuremberg,

1202 — Increasingly widespread veneration of the Virgin Mary. 1203 — Court jesters become a widespread phenomenon.
1204 — The 4th Crusade under Venetian leadership occupies and sacks Constantinople.

"The other, Giotto by name, was of so excellent a mind that among all the things that Mother Nature has created beneath the circle of the heavens, there was not a single one that he had not so faithfully reproduced with his pen and stylus that his work seemed to be not the likeness of the thing, but the thing itself. Thus it often happened that people's visual sense failed when confronted with his work, and they took for real what was only painted."

Giovanni Boccaccio

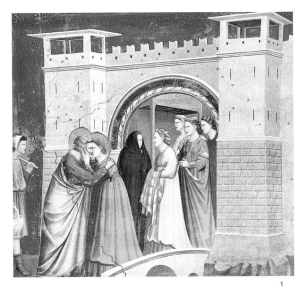

1. GIOTTO DI BONDONE

<u>Anna and Joachim Meet at the Golden Gate</u>
1303–1305, Fresco, c. 185 x 200 cm
Padua, Arena Chapel (Cappella degli Scrovegni all'Arena)

1

Cologne, Bruges, Antwerp, Barcelona, Burgos, Lisbon and even Paris allowed themselves to be influenced at most only superficially by the new art. On the Iberian peninsula, still closely tied to the arabesques and surface ornament of Islamic art, the Gothic style would remain dominant until well into the 16th century, and from there even gain a foothold in the new colonies. In Spain and Portugal, as partly also in England and Germany, the Gothic was so strong that it was able to absorb the forms of the Renaissance without relinquishing its own fundamental structures. In certain places where the Renaissance had never really taken hold, it was thus able, after 1600, to pass almost unnoticed into the vocabulary of the Baroque.

The Gothic thereby remained the prevailing style in very different parts of Europe for well over 300 years – longer than the Romanesque before it, and considerably longer than both the Baroque which came after and the second International Style of the 20th century, the three other artistic trends which dominated all Europe and, latterly too, those overseas cultures strongly stamped by the Old World. The power it continued to house was reflected in the Gothic Revival which arose in England after the decline of the Baroque, and which spread to Germany and ultimately to the USA and even Australia.

What makes up the Gothic style is not quite so easy to grasp in painting as it is in architecture, where pointed arches, rib vaults and multiple-rib pillars usually offer rapid points of reference. What distinguishes Gothic painting is first of all a predominance of line, be it scrolling, undulating or fractured, and ultimately an ornament tied to the plane.

This calligraphic element may be seen as a fundamental constituent of the Gothic style. It is found in its purest form in the gently undulating hems of robes in French painting and sculpture towards

1300, and above all in the draperies which fall in cascades, like thickly waving locks of hair, from the bent arms of figures viewed side n. The style rapidly spread across a broad geographical area; it can be seen in Sweden and Norway by the first third of the 14th century. The rich play of draperies reaches its high point in the years around 1400. Granted a presence virtually of their own by their emphasis and size, they now frame figures viewed frontally.

Draperies in the preceding Early and High Gothic periods assume – again in painting as in sculpture – a far greater variety of expressions. Predominant, however, are thinner, closer-fitting robes with long, parallel folds. Narrow pleats are common. In the final phase of the Gothic style, which follows a "Baroque" phase of overspilling, rounded folds, one stereotype replaces another. While robes remain lavishly cut, their folds now assume a crystalline sharpness. Analogous to the draperies, hairstyles and beards are characterized by thick, regular curls.

This emphasis upon line in the Gothic figure is paralleled by a symbolic and ultimately unnatural stylization of the human body itself. The contours of even the earliest Gothic figures are lent a rhythmic sweep. Particularly characteristic of this trend are the frequently very high-waisted figures of the 14th century, whose silhouettes often trace a decidedly S-shaped curve. This love affair with line cannot be entirely divorced from another constituent of the Gothic ideal, namely the very slender, oval facial type which remains a constant throughout the entire period, regardless of all new trends and changing ideals.

Such pointers can only highlight the most obvious features of an epoch; they cannot do justice to all its individual expressions. Thus within High Gothic sculpture there exists a small group of works which come extraordinarily close to the harmonious proportions of the classi-

1209 — Work starts on the first Gothic building in Germany, Magdeburg Cathedral. 1213 — In Bologna a medical faculty
is set up alongside the faculty of law. 1216 — In Toulouse Dominic founds the order named after him.

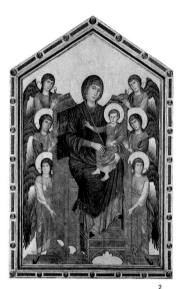

2. CIMABUE

Maestà (Madonna Enthroned)
c. 1270 (?), Tempera on wood, 427 x 280 cm
Paris, Musée du Louvre

3. DUCCIO DI BUONINSEGNA

Rucellai Madonna (Maestà)
c. 1285, Tempera on wood, 450 x 290 cm
Florence, Galleria degli Uffizi

4. SIMONE MARTINI

Maestà
1315/16, Fresco (detail), 10.58 x 9.77 m (total size)
Siena, Palazzo Pubblico, Museo Civico

cal human figure. In the midst of the extremely refined art of the French court in the years around 1300, there suddenly appear flat faces of strikingly broad and angular outline, which subsequently became one of the most distinctive features of Lotharingian Madonna statues. In painting, Master Theoderic (doc. from 1359 – c. 1381; ills. pp. 44, 45) set himself apart from the overrefinement and stylization of the Master of Hohenfurth (active c. 1350; ill. p. 11) and the Bohemian Master of the Glatz Madonna (active c. 1345; ill. p. 43) of just ten years earlier with the powerful, heavy heads of his massive, thickset saints. Here, as never before in Western art, they are people of real flesh and blood. One of his colleagues, later known as Master Bertram of Minden (c. 1340–1414/15; ills. pp. 11, 51), emulated him to some degree, but overall Theoderic's excursion into powerful individualization was carried no further.

The birth of the new style

Even more problematic than the term "Gothic" itself is the precise dating of the period to which it was posthumously applied. Its regional variations, too, demand more specific differentiation. In contrast to what Vasari would have us believe, the Gothic style had its origins not in the Germanic north, but in France, where large numbers of classical buildings were in fact still standing in Vasari's own day. It was the intensive study of these very remains – and not some anti-classical reaction – that inspired the development of Gothic forms of ornament and a new image of man. Thus some of the most impressive examples of French cathedral sculpture owe their origins to this appraisal of antiquity – decades before, towards the end of the 13th century in Rome, the painters Pietro Cavallini (c. 1240/50? – after 1330), Jacopo

Torriti (active c. 1270–1300) and Filippo Rusuti (active c. 1297–1317) turned their attention to their classical heritage and thereby laid the foundations for Giotto's revolution.

In St Denis, even before 1150, Abbot Suger (c. 1081–1151) "invented" the ribbed vault which, with its pointed arches and large windows, would lay down the ground plan for the ambulatories of Gothic cathedrals. Elsewhere, however, much remained indebted to the Romanesque style. Even as High Gothic architecture in the region around Paris entered its classical phase with the construction of Chartres at the start of the 13th century, in neighbouring countries, on the Rhine and in Spain, buildings were still springing up in the excessively ornamented style of the Late Romanesque. The new style was not embraced synchronously by all of Europe at once, but rather was adopted by different disciplines of art at different points in time. Even amongst the painters of the French court, old Byzantine traditions persisted into the 13th century. Only towards the middle of the century does a genuinely Gothic style become palpable in painting – an entire century later than in architecture. German and Italian painting, meanwhile, were being swept at the very same time by a fresh wave of Byzantine influence.

On the other hand, this Late Romanesque phase bore the appearance, in Germany in particular, of a rearguard action. The more naturalistic proportions being employed in the portrayal of the human figure and its draperies by their French neighbours had not escaped the notice of the German painters. Instead of adopting this new development directly, however, they took its powerfully animated robes and stylized them – in a Byzantine manner – with crystalline folds, arriving at what has been aptly termed the zigzag style. This style is found in England, too, although the country's close artistic ties to France also produced more naturalistic forms.

1220 — Frederick II is crowned Emperor.

1221 — Francis of Assisi founds the mendicant order named after him, with strict rules of poverty.

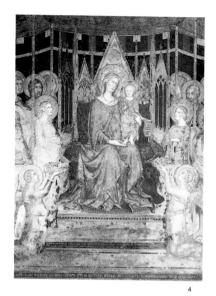

4

> **"ᴅuccio endeavoured to imitate the methods of the ᴀncients, and used his good judgement to give the figures attractive forms, which he ... executed in excellent fashion."**
>
> Giorgio Vasari

The Italian works included in this volume also commence with the end of the 13th century. Although they do not fall under the heading of Gothic painting as such, they exerted an enduring influence upon the Gothic style from almost the very start – and did not remain untouched in return. Their artistic starting-point was the Byzantine Empire, which began on the eastern shores of the Adriatic and which enjoyed close political and cultural links with many of Italy's cities. A series of four Madonna panels, one by the Sienese artist Duccio di Buoninsegna (c. 1255 – c. 1319; ill. p. 8), two by the Florentine Cimabue (c. 1240 – after 1302; ills. pp. 8, 31), and one by his compatriot Giotto (ill. p. 33), might almost have been deliberately designed to illustrate the magnitude of the development which took place within just one generation. Three of them hang in the same room in the Uffizi in Florence.

In all four pictures, the Virgin is seated on an elaborate throne. In the Duccio and the earlier of the two Cimabue paintings, this tapers illogically towards the foreground; a vague attempt at the perspectival effects achieved by earlier generations – right back to classical antiquity. In the two later works, on the other hand, the throne vanishes towards the background. The three earlier thrones are ornately fashioned of wood, while Giotto's throne is constructed out of costly stone. We are suddenly confronted with an entirely new vocabulary of form. Above the sides and back of the throne, Giotto deploys pointed arches, trefoil tracery, finials and crockets – the language of Gothic architecture, in other words, already in use in France for over a hundred years, but still very new to Italy. The façades of Siena and Orvieto cathedrals, built during this same period, feature very similar elements and also employ a wealth of coloured marble and costly inlay. While Giotto's throne draws upon the decorative motifs of Islamic art, its curling

leaves and scrolling tendrils at the same time anticipate the ornament which three centuries later would fill the pilasters of the Renaissance.

The very similar poses adopted by the Virgin and Child in the Giotto and the earlier Cimabue suggest that both works looked back to the same Byzantine model. The later Cimabue painting adopts a similar basic format, although the Madonna is seated slightly differently. In the Duccio and both Cimabue paintings, the figures are detailed with extreme care and the folds of their robes rendered with great subtlety. The calligraphic fluency with which Duccio drew the edges of the Virgin's cloak is underlined by the gilding. Despite their angled poses, however, with their knees bent at different heights, the three earlier Madonnas ultimately lack true physical substance. They appear to float like cutouts against their lavish backgrounds.

Once again, Giotto does something entirely new. A solid body fills out the draperies; languid, delicate fingers become firm and fleshy. Where robe and body once formed an elegant unity detached from the world, so here a very earthly mother seems to have donned her costly robe purely and uncomfortably for ceremony's sake. Both feet are planted side by side firmly on the ground. In the two earliest paintings, in particular, the Virgin's face reveals the same overly wide bridge of the nose and a mouth which is much too small in relation to the almond-shaped eyes. The modelling of the face has a very graphic quality; line dominates. Thus the artist even draws in the side of the nose upon which the light falls. In Giotto this gives way to blurring shadow; a delicate gauze lies around the eyes, the forehead broadens, the veil sits higher on the head.

While their closely pleated draperies reflect the ethereal remoteness of the earlier Madonnas, in Giotto both the figures and the fabrics have become heavy and solid. The Virgin's cloak falls into just a

1229 — Emperor Frederick II is named King of Jerusalem at the end of the 5th Crusade.

1232 — Emperor Frederick II makes his court in Palermo a centre of the arts.

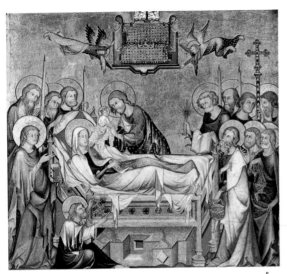

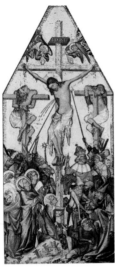

few, large folds. Although the three earlier paintings also attempt to differentiate between raised and sunken areas of fabric, the gold on and between the ridges of the red shawl draped around Duccio's infant Christ, and on the Virgin's robes in the later Cimabue, only serve to accentuate the flatness of the overall effect. Giotto, by contrast, already makes highly convincing use of light and shade, limiting gold to the no longer capriciously undulating, but largely flat hems of the Madonna's cloak. What is true of the Virgin and Child is also very much true of Giotto's angels. They are no longer surface decoration, but large, serious figures who, for all their wings, stand or kneel with their full weight on the ground. The lilies and other carefully rendered flowers in their hands also introduce, over and above their symbolic significance, a very robust, earthly element into the exalted heavenly sphere. The fact that Cimabue and Duccio had already freed themselves significantly from the dominant Byzantine style, and had arrived at a more naturalistic treatment of movement, draperies and the distribution of light and shade, is entirely obscured by the force of the revolution wrought by Giotto. His radical change of direction continues to astonish the modern viewer – how much more profoundly it must have shaken his contemporaries. Notwithstanding its Roman predecessors and the influences of antiquity and the French Gothic style, it remains one of the great acts of creation in the history of art.

It was improved upon even in Giotto's own lifetime in the work of the barely less important Sienese artist, Simone Martini (c. 1280/ 85–1344). In comparison with Giotto's sculptural, block-like figures, with their often correspondingly stiff, awkward, even clumsy gestures, Duccio was already painting with a greater subtlety. Where Giotto portrays raw size, Duccio's figures, more heavily indebted to Byzantine tradition, exhibit greater feeling. Duccio's colours, often deeply shaded,

shimmer like costly enamel. Although the early works of Simone Martini, born barely twenty years after Giotto, were still characterized by such Byzantine features as the broad bridge of the nose and draperies overlaid with gold leaf, he went on to marry Duccio's achievements both with the new physical type introduced by Giotto and with Giotto's revolutionary understanding of space and architecture.

Simone's enormous Maestà fresco in Siena's town hall, depicting the Virgin and Child enthroned and surrounded by saints, is distinguished by a particular elegance and beauty of line (ill. p. 9). Movements are freer, and faces – highly sensitive and often very serious – are more finely modelled and strongly expressive than those of Giotto. While the bearded heads are still largely indebted to Duccio, the slender youthful heads, many of them with half-length hair curling in on itself at the bottom in line with the fashion of the day, are often more "Gothic" than Giotto's. Simone's draperies are again thinner than Giotto's, and their folds more angular. Compared with the plainness of the Florentine master, what is striking overall is the wealth of detail in both the costumes and the setting.

The innovations pioneered by Giotto and Simone are not simply milestones within the history of Italian art. They serve to illustrate the interplay of mutual influences within non-Byzantine art as a whole, as well as the phenomenon of chronologically staggered developments. Just as Giotto and Simone had absorbed influences from France, so they in turn helped steer painting north of the Alps down entirely new avenues. Even before Giotto's death in 1337, one of the four panels making up the altarpiece for Klosterneuburg near Vienna (ill. p. 10), completed around 1331, quotes literally from the frescos which Giotto executed in 1304–1306 for the Arena Chapel in Padua (ill. p. 7) – one of the first Italian cities which travellers reached after crossing the

1238 — Granada is the flourishing capital of an autonomous Moorish empire.

1245 — Book illumination and stained glass become popular especially in France.

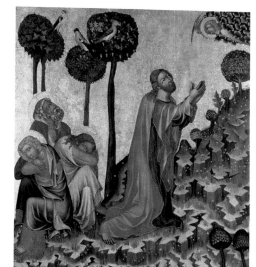

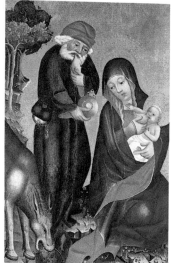

7. MASTER OF HOHENFURTH

<u>The Agony in the Garden</u>
from the Hohenfurth Altar
c. 1350, Tempera on canvas on wood,
100 x 92 cm
Prague, Národni Galeri

8. MASTER BERTRAM OF MINDEN

<u>Rest on the Flight to Egypt</u>
from the former high altar, or Grabow Altar
c. 1379–1383, Mixed technique on wood
Hamburg, Hamburger Kunsthalle

7

8

Alps. The remaining three Klosterneuburg panels also testify to the influence of the great Florentine master in their angular faces, austere gestures and in the foreshortening and decoration of their furnishings. That their anonymous artist was nevertheless rooted in the contemporary trends of the North is demonstrated, on the other hand, by the greater animation and curvilinear silhouettes of his figures, and above all by the loose draperies with their richly undulating hems in which they are clad.

A good ten years later we encounter Italian influences again, this time a little further north in Prague, Bohemia, which under Charles IV (1316–1378) became the seat of the Holy Roman Emperor and thus the political as well as the cultural capital of the entire empire. The Bohemian Master of the Glatz Madonna (ill. p. 43) and his somewhat weaker follower, the Master of Hohenfurth, cite Italian head types more faithfully than the Klosterneuburg artist, while the folds of their draperies continue to reflect the tastes of the North. As the *Kaufmann Crucifixion* (ill. p. 10) demonstrates, an exquisite palette featuring striking orange accents becomes characteristic of the Bohemian school, although it could also be seen as a reference to earlier Sienese paintings. The same might be true of the sumptuous detailing of the draperies of the Christ, donor and angels in the Glatz picture. The large panel was originally surrounded by smaller scenes from Christ's childhood, as was the convention in Italy. This was no coincidence: to underline his imperial status, Charles IV was quite blatantly seeking to compete with the leading artistic centres of his day – which meant Tuscany and Paris – and if possible even to surpass them.

The Italian influences finding their way into the Klosterneuburg altar were also being felt strongly in Paris, where the French court was the most spoilt for artists of any in Europe. In 1309, under pressure

from the French king Philip the Fair, Pope Clement V (1305–1314) moved his residence from Rome to Avignon, which was closely allied to the French crown lands. He was followed not just by cardinals and the papal court, but also by Italian artists, including for a short time possibly even Giotto himself. Simone Martini certainly spent time in Avignon. He was destined for employment at court not only by the extremely sophisticated elegance of his art, but also by the close contacts he had developed, while still in Italy, with the Anjou family, the then rulers of Naples.

The panel paintings which Simone executed after 1336 are now scattered, but important fragments of his mural decorations for the palace chapel have survived in situ. As a result of conservation measures undertaken in this century, it is even possible to distinguish between the various stages of their execution. The rather damaged frescos themselves have been detached from the detailed preparatory drawings, or sinopie, underneath and these separated in turn from the original sketch, which remains in its old place. The sinopie, hidden for six hundred years, thereby reveal the delicacy and freedom of Simone's drawing more directly than the finished painting.

From Avignon, the exquisite linearity and powerful, delicate colours of the Sienese artists exerted their influence not only upon the Paris court, where Jean Pucelle (active c. 1319–1335) drew upon them to arrive at a new plasticity and sought to achieve a uniform perspective, but also upon nearby Aragon across the Pyrenees. Even the Sienese elements of Bohemian court art may have reached Prague via Avignon rather than a more direct source – men such as the bishop who commissioned the *Glatz Madonna* were bound to have spent time at the papal court. Nor should we underestimate, in this context, the extent of the artistic exchanges taking place in

1260 — The earliest complete series of depictions of Christ's Passion are displayed.

1252 — Starting in Italy, a gold coinage spreads throughout Europe.

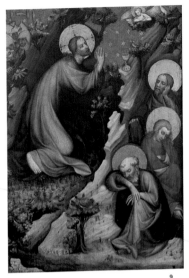

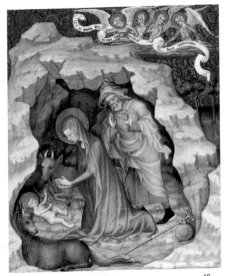

9 10

Avignon itself. According to records, the Italians were working along-side English, Catalan and, in particular of course, French artists.

Pathways to the international style

Even as an important basis was here being established for the extraordinarily homogeneous style that would stamp itself upon the art of western and central Europe around 1400, so in Tuscany Giotto and Simone Martini had set standards which were almost impossible to surpass. For their contemporaries and followers, consequently, it was a matter of consolidating what had been achieved rather than of embarking upon something new. In Siena, such important painters as Lippo Memmi (active 1317 – c. 1350) and Pietro Lorenzetti (c. 1280/ 90–1348; ill. p. 13) further developed the art of Simone, while in Florence Taddeo Gaddi (active c. 1325–1366; ill. p. 14) and others embraced the legacy of Giotto. A certain artistic paralysis now set in. A contributory factor here was the outbreak in 1348/49 of the Black Death, which spread throughout Europe in just a few months and in some places carried off over half the population, including many artists – Pietro Lorenzetti perhaps among them. Stagnation and increasingly empty routine would make the Italian artists only too eager to embrace the new trends of the International Gothic towards the end of the century.

New impetus would eventually come from the northern centres of Paris and Prague. While the trauma of 1348 continued to be processed in many places in extremely expressive Crucifixions and Lamentations, the forerunners of the International Gothic were already formulating the new style which, around 1400, would dominate the whole of non-Byzantine Europe. At almost the same time as Theoderic was painting his monumental, melancholy saints for Karlstein castle (ills. pp. 44, 45) – the crystallization-point of Charles IV's cultural, political and religious ambitions – the Prague sculptors were unveiling their quite different art, its figures more stereotypical than individual, more elegant than earthly. Their influence immediately began radiating out to neighbouring Silesia, which belonged to Bohemia, and on to Salzburg.

There were enough branches of the Parler dynasty of artists alone to ensure close exchanges with the Rhineland. Characteristic features of this Prague school include Lamentations and, above all, the aptly-named Schöne Madonnen ("Beautiful Madonnas"). Along-side their technical perfection, these latter are distinguished by the dynamic sweep of their bodies, an affected pose, faces of an almost saccharine sweetness and in particular a volume of draperies arranged with consummate skill, which tumble down the sides in rich cascades and conclude in a virtuoso sea of undulating hems.

Judging by the quality, number and geographical spread of the works which followed, this aesthetic revolution must have captivated other artists of the day as far away as Italy and even distant Spain. At home, it was translated into painting by the Master of Wittingau (active c. 1380–1390), the last great artist which the Bohemian school, which flowered for just a few decades, would produce. He underlines once again the importance of the new style not just for Bohemia, but for Europe as a whole: almost all the elements which would be central to European painting around 1400 are present in his *Wittingau Altar* (ills. pp. 12, 53). Theoderic's ample figures are reduced to an almost painful thinness: extremities, faces, all are now elongated and fragile; fingers resemble spider's legs. The slender silhouettes are clad all the more expressively in thin, generously cut robes. In a similar fashion

1271 — The Venetian Marco Polo travels through Asia as far as Peking.

1280 — Florence develops into western Europe's leading business centre.

9. MASTER OF WITTINGAU

<u>The Agony in the Garden</u>
from the altar of the Augustinian
Canons' church of St Aegidius
c. 1380–1390, Tempera on wood, 132 x 92 cm
Prague, Národni Galeri

10. MASTER OF THE NARBONNE PARAMENT

<u>Adoration of the Child</u>
Miniature from the
<u>Très Belles Heures de Notre-Dame</u>
c. 1390 (?), fol. 4 v, Body colour on parchment,
29 x 21 cm (dimensions of page)
Turin, Museo Civico d'Arte Antica

11. PIETRO LORENZETTI

<u>Deposition</u>
c. 1320–1330
Fresco, 232 x 377 cm
Assisi, Lower Church of St Francis

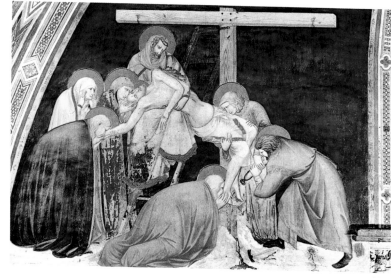

11

to the sculptures mentioned above, the Christ in the Resurrection is enveloped in a cascade of folds ending in a rich swirling hem. Anecdotal details have assumed much greater importance – even where, as in the case of the many birds in the Resurrection, there is little obvious justification for their inclusion in the scene.

The quality of the execution struggles to match the inventiveness of the composition, however. As in the case of the Hohenfurth Altar, the paintings that have come down to us are perhaps only indirect reflections of the true, but now lost masterpieces of their day. There is another striking feature about the *Wittingau Altar.* As remained the convention in various regions up to the 16th century, the majestic gold ground is restricted to the interior panels, which in Wittingau are reserved – again in line with convention – for standing figures of saints. The narrative scenes on the altar's exterior, on the other hand, employ a red ground dotted with gold stars, which engages in a powerfully expressive interplay with the red of certain draperies. The impression made by the landscape, with its individual elements executed in such particular detail, is also intensified by the complementary colour of the background. There may have been earlier instances of this phenomenon, too, in works that are now lost.

This style had its roots in the Paris court art of the years around 1300, where its forms battled against more abstract tendencies throughout the 14th century. Years before the *Wittingau Altar,* the Parisian Master of the Narbonne Parament (active c. 1375 – c. 1400) had demonstrated, in the work which gave him his name (ill. p. 12), his familiarity with the elegant flow of movement, slender silhouettes and the exuberant undulation of fabric hems.

In the thirty years following the completion of the Wittingau Altar, non-Byzantine painters everywhere competed in their striving towards an ever more exquisite palette and ever more fluid draperies; not without reason is the International Gothic also known as the Soft or Beautiful Style. For the first time, lovingly detailed landscapes became a major element of the composition. For the last time before the Baroque, western European painters shared the same vocabulary, the same aesthetic ideals. Even Italy, entrenched in its old traditions, eagerly embraced the new trend, to the regret of later Renaissance theoreticians of the school of Vasari; the supposedly unbroken line of development from Giotto to Michelangelo (1475–1564) is a later myth. Gentile da Fabriano (c. 1370–1427; ill. p. 14) and Pisanello (before 1395–1455; ill. p. 15) were leading figures in both Italian and Gothic art. It is no coincidence that Milan cathedral dates from precisely this period, as a symbol of the triumph of Northern form. There are sociological reasons, too, behind this broad-based stylistic uniformity: the ruling houses of the day were dominated by very similar courtly ideals, which were also finding their way into literature.

What is so truly astonishing about this epoch is the fact that the style was practised so widely, including by many unknown and second-rate artists. But it was also embraced by some of the greatest names in Gothic painting. Apart from Gentile and Pisanello, these included Jean Malouel (c. 1365–1419, ill. p. 16) and Melchior Broederlam (doc. 1381–1409; ill. p. 17) in Paris and the Burgundian capital of Dijon, the Master of the Wilton Diptych (doc. c. 1390–1395; ill. p. 55) in London (?), Lluís Borrassà (doc. from 1380 – c. 1425/26; ill. p. 17) in Catalonia and, in the wealthy Hanseatic city of Dortmund, Konrad of Soest (c. 1370 – after 1422), who would exert an enormous influence upon west and north German art for decades to come (ill. p. 20). All of these artists sought to place their own stamp upon the universal style.

1285 — The mendicant orders make preaching a major feature of the Christian mission.
1290 — The first glazed windows in private houses appear.
1291 — The Age of the Crusades comes to an end.

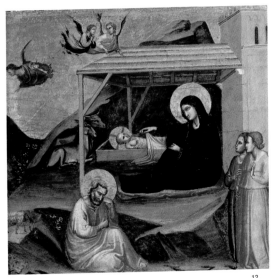

12. TADDEO GADDI

Nativity
c. 1325, Tempera on wood, 35.5 x 37 cm
Madrid, Museo Thyssen-Bornemisza

13. GENTILE DA FABRIANO

Adoration of the Magi
1423, Tempera on wood, 303 x 282 cm
Florence, Galleria degli Uffizi
(formerly in Santa Trinità, Capella Strozzi)

14. PISANELLO

The Vision of St Eustace
c. 1435, Tempera on wood, 55 x 65 cm
London, National Gallery

12

New departures in Florence and the Netherlands

It was clear by the 1420s at the latest that this rare parallelism would not be a lasting phenomenon. While the Soft Style reached its final flowering in a work such as the *Ortenberg Altar* (ill. p. 19) – admittedly accompanied by an increasing hardening and stylization of the heads – artists elsewhere had already made a sudden, apparently unexpected break with the past which, like the new departures of Suger and Giotto, would be followed by a period of consolidation and relative quiet. In Florence, Masaccio (1401–1428) and Masolino (1383 – after 1435) were laying the foundations of the art of the Renaissance, by infusing Giotto's forgotten compositional formulae with a greater realism and a previously unknown monumentality, derived in turn from a deeper study of antiquity and a closer observation of their own surroundings and the human form. The fragile bodies of the International Gothic are filled with new volume, stances become heavy, profiles broad, shadows deep. In the southern Netherlands, meanwhile, the second great centre of power in western Europe was starting to emerge. Towards the end of the 14th century, Netherlandish artists were already exerting a decisive influence upon developments in Paris, up till then the artistic capital of the North.

Parallel with the new developments in Florence, the brothers Hubert (c. 1370–1426) and Jan van Eyck (c. 1395–1441) – the most important Netherlandish artists of the age – were also turning to the naked human body and lending it a realism unseen since antiquity (ill. p. 18). The paths they followed to the same goal were very different, however. In the case of Masaccio (ill. p. 18), it was a highly intellectual process. His image of humankind is concentrated into archetypes. He is more interested in basic form, flow of movement and volumes than in the surface of things. It was the accurate observation of such surfaces, however, which formed the foundation of Eyckian realism, but which also contained its limitations. Jan van Eyck described the effects of movement without actually understanding them. Thanks to this same eye for detail, however, he succeeded in lending his figures an anatomical quality whose impact was felt even in Italy. Only van Eyck discovered the dimple on Adam's hip, only he described the muscles and sinews around Adam's knee.

Netherlandish empiricism went an astonishingly long way. While Jan van Eyck's contemporary, Filippo Brunelleschi (1377–1446), was "inventing" centralized perspective in Florence, his own pictures contain no unified vanishing point. If his spatial settings frequently seem highly "realistic", it should not be forgotten that the mathematical principles of perspective employed by the Italians strictly speaking contradict the workings of the human eye, which sooner perceives slightly curved lines as straight rather than ones which really are straight. Perspective employing a consistent vanishing point would only find its way into Netherlandish art in the second half of the 15th century.

The Netherlandish love of detail could be celebrated to its fullest in portrayals of untamed nature. Although landscapes as a whole were conceived on a less grandiose scale than in Masaccio, the natural kingdom is portrayed with a precision, technical sophistication and exquisiteness which remain unequalled today. However different in other respects, even the Italian painting of the Quattrocento regularly drew fruitful inspiration from this same source. Thus the young Raphael was not shy of siting his figures again and again within a Netherlandish natural idyll. This influence of the North upon the South nevertheless still tends to attract much less attention in the literature than the exchanges in the opposite direction.

1294 — The medieval commercial centres form the Hanseatic League.

1300 — Numerous mini-states form in Italy, some of them destined to become major powers in the centuries to come.

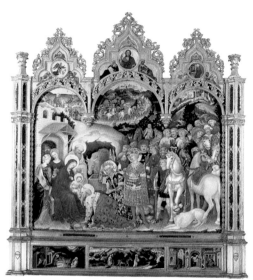

13

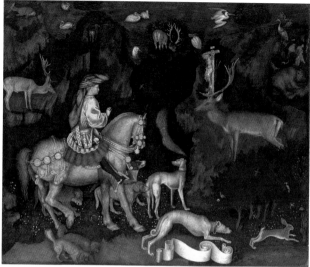

14

It has, however, long been known that Northern works were eagerly collected south of the Alps. On closer inspection, it thus emerges that an astonishingly high proportion of the works of Hans Memling (c. 1430/40–1494; ill. p. 89) were destined for Italian lovers of art. Rogier van der Weyden (c. 1400–1464; ill. p. 70 f.) and Hugo van der Goes (c. 1440–1482, ill. p. 93) both dispatched their paintings across the Alps; Joos van Cleve (c. 1485–1540/41) would later send his biggest altars there. Significantly, a large work by Gerard David (c. 1460–1523) for Liguria even modelled itself on the layout of the Italian altarpiece. Down in the far south of Italy, Antonello da Messina (c. 1430–1479) became the champion of Netherlandish ideas possibly without ever having crossed the Alps. Most exciting of all within this process of exchange are the rare personal meetings between artists, such as the work jointly executed at the court of Urbino by the Italian Piero della Francesca (c. 1415/20–1492), the Flemish artist Joos van Gent (active c. 1460–1480) and the Spaniard Pedro Berruguete (c. 1450–1503?). So close and fruitful was their collaboration that trying to identify exactly who painted what continues to cause headaches even today.

The reciprocal influences passing between North and South are illustrated particularly clearly in the backgrounds of the paintings of this era. In England, France and Germany from the final third of the 13th century to the second half of the 14th century, there was a preference for decorative, often very complicated and fussy geometric patterns. They live on even in the work of the otherwise anything but conservative Theoderic, and continue to find echoes in the 15th and even early 16th century, not least in the ornamental gold grounds of the Cologne painters (ills. pp. 58. 59) and in particular Stefan Lochner (c. 1400–1451; ills. pp. 21, 77).

Making an increasing appearance in the North towards the end of the 14th century are backgrounds of plants and flowers, which soon after 1400 reach an at times breathtaking magnificence. The Master of the Paradise Garden (ill. p. 57) renders each different species in loving detail. But whereas he presents the plants one by one as if in a botanical textbook, the van Eyck brothers weave them, barely twenty years later, into an organic whole. Grasses no longer stand out palely against a dark ground, as if on a carpet. Here, at least in places, we sense the rampant, untamed growth of nature, following no human rules.

The development of the portrayal of whole landscapes progressed with similar speed. While Giotto observed people and buildings with great care, the rugged, rocky hillsides of his outdoor settings remain for the most part a backdrop of secondary importance. Although he attempts to differentiate trees and plants by species, they remain something of an abbreviated representation of the riches of nature. At the hands of Simone Martini just one generation later, what was simply a foil becomes luxuriant green gardens within which (and not in front of which) the figures act out their parts. In the frescos in the Palazzo Pubblico in Siena (ill. p. 7), panoramas are no longer accessories, but the true protagonists. For all their stylization, they portray familiar real-life landscapes, albeit recognizable more from their architecture and embellishing details than from their barren sugar-loaf hill. When Ambrogio Lorenzetti (c. 1290 – c. 1348) painted the *Effects of Good Government* (ill. p. 23) in the same building, also well before the middle of the 14th century, he too chose a realistic landscape over a symbolic or allegorical setting. In a broad panorama, he shows the Tuscan hills with their fields, hedges, olive trees and vineyards.

In the North, it would be over fifty years before the three brothers Paul, Jean and Herman Limburg (active c. 1400–1415) would

1301 — Halley's Comet is observed.
than in other European countries.

1303 — Murals achieve greater importance in Italy
1311 — Rheims Cathedral is completed.

15

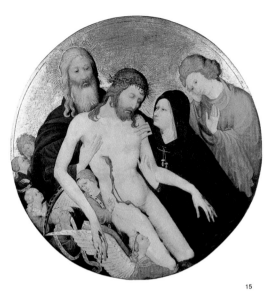

15. JEAN MALOUEL

Pietà (La grande Pietà ronde)
c. 1400, Tempera on wood, diameter 64.5 cm
Paris, Musée du Louvre

16. MELCHIOR BROEDERLAM

The Presentation in the Temple and
The Flight to Egypt
from the Chartreuse de Champmol Altar
1394–1399, Tempera on wood, 167 x 130 cm
Dijon, Musée des Beaux-Arts

17. LLUÍS BORRASSÀ

Nativity from the altar from Santes Creus
1403–1411, Tempera on wood, 184 x 121 cm
Barcelona, Museu Nacional d'Art de Catalunya

15

produce landscapes painted with the same loving attention to detail, but often much more fantastical in character (ill. p. 22). As in the Siena frescos, the identifiable buildings within them serve specifically to reflect glory upon the patron of the work of art concerned. Thus in Siena they proclaimed the success and sphere of influence of the city, while in the *Très Riches Heures* they reflected the magnificence of the properties owned by the Duc de Berry, for whom the manuscript was executed.

Fantastical, too, are the landscapes of Melchior Broederlam in Dijon, which usher in Early Netherlandish painting. Their architecture and rugged cliffs employ formulae which had been developed in Tuscany almost a century earlier, and which had then travelled north, for example via Klosterneuburg and Hohenfurth. Although the *Nativity* by Robert Campin (c. 1375/80–1444; ill. p. 65), also executed for Dijon towards 1430, still employs a snaking track to draw the eye into the background, its route is now bordered by set pieces from the 15th-century viewer's world. Pollarded willows, wicker fencing, fields and contemporary buildings lead towards a distant lake. The rocky outcrop blocking the view has moved to a less obtrusive position above the stable, and appears at least a little more realistic with its patches of turf between bands of rock. At the same time, the landscape is no longer seen entirely from above, but is presented in a more accurate relationship to the figures in the foreground.

A good decade would pass before Konrad Witz (c. 1400–1445) painted, in 1444, a recognizable landscape which no longer relied upon cities and castles for its identification (ill. p. 75). The following years subsequently saw the give and take relationship between South and North reversed. The stylized landscapes of the North, far removed from realism in the modern sense, were enriched by such a carefully-observed wealth of natural detail that even Raphael was unable to resist their charms.

Landscape was just one of the temptations drawing collectors to buy Netherlandish art and painters to imitate it. Another was the quality of execution distinguishing its panel paintings, whose standard was never to be equalled. The very wood itself was chosen with particular care. While artists in Italy generally made do with local poplar, and in Spain with pine, in the Netherlands virtually everyone opted for Baltic oak, which was shipped in from far afield. The panels were cut out of the trunk in radial wedges, like slices of cake, in order to prevent any later warping. The softer outermost layers were rejected, so as to forestall any unnecessary extra risk of attack by insects. As a further means of protection, the panels were given solid frames and only then primed, usually on both sides. The wood was thus sealed all round.

As a consequence, the practice of covering the panel with a layer of material, still very common in the 14th century and seen, for example, in the *Kaufmann Crucifixion* (ill. p. 10) and the *Schloss Tirol Altar*, could be largely dropped. On top of the primed panel, whose white ground was intended to shine through the colours laid over it and thereby heighten their luminosity, there was often then executed a detailed preliminary drawing. Only after weeks of preparation, and years even since the original tree had been felled, could painting actually begin. This, too, was an extremely laborious and lengthy process. By no means was the final colour applied straight away (alla prima). Rather, the paint was laid down in several transparent layers (glazes), moving from darker to lighter shades, allowing the underlying layers to shine through. This alone would ensure the tremendous luminosity, durability and exquisite enamel-like sheen of Early Netherlandish panel paintings. Towards the end of the century the number of glazes

1317 — A famine decimates Europe's population.

1321 — The University of Florence is founded.

1326 — Francesco Petrarca (Petrarch) takes up writing following the end of his studies.

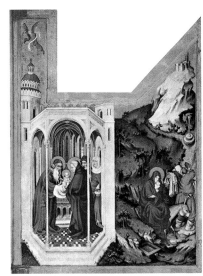
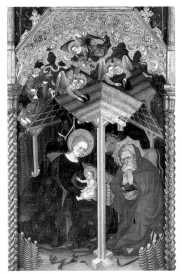

was gradually reduced, and on occasions in the early 16th century, the white ground or the preliminary drawing was deliberately allowed to shine through.

The paints themselves were naturally not available ready-mixed. Workshop duties in the late Middle Ages included not just painting, but also grinding the pigments. The degree of fineness of the powder thereby influenced the colour it produced. Thus azurite, the most commonly-used blue pigment of the day, only gave a blue effect if it was not ground too finely. A second, important blue pigment was ultramarine. While it offered a greater and more gem-like luminosity, it was obtained from lapis lazuli, which had to be imported from the Orient, from modern Afghanistan, and was thus more expensive than gold. Significantly, it was employed with great regularity by the first generation of Early Netherlandish artists, but only extremely sporadically by the technically less ambitious German artists of the day.

Other than in Cologne or even Italy, the Netherlandish artists had almost entirely dispensed with gold, seeking instead to heighten the illusion of reality with a permanently blue sky over a white haze. Areas of gilding, whether grounds, haloes or drapery details, involved a variety of complex procedures. For example, where they were to be given an additional relief pattern by means of pouncing, in other words the hammering of small indentations into the metal, the layer of primer beneath them had to be considerably thicker. Also required was an intermediary bole ground, usually reddish in colour, to which the wafer-thin leaves of precious metal would adhere.

According to the author of the best-known treatise on artists' materials of his day, the painter Cennino Cennini (c. 1370 – c. 1440), pupil of a son of Taddeo Gaddi and thus a "great-grandpupil" of Giotto, one Florentine gold coin yielded a hundred sheets of gold leaf barely the size of the palm of a hand. After the leaf had been laid, it was burnished with a gemstone or a tooth in order to bring out its fascinating sheen. To avoid unnecessary expense, the inclusion of gilded areas within a painting had to be carefully planned in advance. Since the gilding was carried out first, before any actual painting began, the artist had to decide exactly where on his panel the costly material was to go. As a rule, no further gold leaf would then be applied to the remainder of the composition.

Lastly, too, there was the choice of the right binding agent. Since the claim was first made by the art historians of the 16th century, Jan van Eyck has long been credited with the invention of oil painting. The reality is much more complicated. Binders containing oil were known as early as the 13th century, even if they were not yet being deployed with their later sophistication. The fact that they can be found in English and Norwegian paintings in particular suggests that artists were already taking into account external factors such as a damp climate. On the other hand, painters in the Netherlands continued to employ egg tempera long after the van Eycks were dead, not least because some pigments failed to mix well with oily binders, which reduced their luminosity.

At the same time, mixed techniques played a far greater role than is generally assumed today. Finally, artists also had to weigh up the characteristics of the individual binders and in particular the oils they employed, since some of them had major implications for the actual painting process. Oils derived from different plants and in different ways dried at different speeds, which meant that in some cases an artist might have to wait many days before the next layer of paint could be applied. This drying process could be speeded up with the help of specific substances.

1339 — Outbreak of the Hundred Years' War between France and England.

1348 — The Black Death rages for two years in Europe.

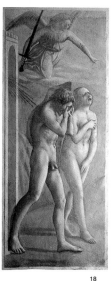
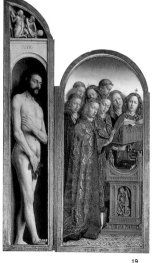

18. MASACCIO

The Expulsion from Paradise
c. 1424/25, Fresco, 214 x 90 cm
Florence, Santa Maria del Carmine,
Cappella Brancacci

19. JAN AND HUBERT VAN EYCK

Adam and Singing Angels from the Ghent Altar
Completed 1432, Oil on wood, 204 x 33 cm (Adam)
and 162 x 69 cm (Angels)
Ghent, St Bavo's cathedral

20. MASTER OF THE HOLY KINDRED

The Holy Kindred from the Ortenberg Altar
c. 1425–1430, Mixed technique on wood,
100 x 162 cm
Darmstadt, Hessisches Landesmuseum

18 19

The artists of the late Middle Ages, and in particular artists in the Netherlands, thus worked within a time frame which, for a public which has grown up with the notion of the artist genius, is almost impossible to grasp. They possessed a detailed knowledge of natural science which, in the following generations and centuries, would increasingly become the sphere of specialist technicians and today the modern chemical industry. Simple, practical calculations were at this stage far more important than the finer points of style, content or even art theory which interest critics and viewers today. Mechanical tasks such as grinding pigments, mixing up paints or burnishing gold grounds took up a large part of their working day. It is only when we take all this into consideration that we start to appreciate why artist apprenticeships in the late Middle Ages generally lasted four years, with the apprentice simply assisting with general tasks at the beginning.

Pictures of St Luke, the patron saint of artists, painting the Virgin provided numerous 15th-century artists with a welcome opportunity to portray the activities of a contemporary artist's workshop. In these we occasionally see an assistant in the background grinding paints. In the painting by Derick Baegert (c. 1440–1515), an angel is lending the Evangelist a hand (ill. p. 24).

The techniques and training described above guaranteed the enduringly high standards and astonishing homogeneity of Early Netherlandish painting which continue to captivate the viewer today. Towards 1500, these same qualities also led it to become a major export not just to Italy, but also to Spain, Portugal and Scandinavia. Mass production, however, inevitably brought about a decline in the rigorous standards of execution which had originally made the school so popular.

changing motifs and artistic originality

A further consequence of the workshop system was that compositional originality played nowhere near the same role in the Netherlands as it did in later epochs or even in contemporary Italy. In the Netherlands of the 15th century, by contrast, compositional solutions, poses and figural types which were judged to be good were handed down over more than a hundred years. Thus the Last Suppers of the period around 1500, for example, employ elements which were already present in the *Last Supper* which Konrad of Soest painted for his Bad Wildung altar of 1403. Providing the richest source of all, however, was the œuvre of Rogier van der Weyden, whose *Descent from the Cross* in the Madrid Prado became the most influential painting of the Early Netherlandish school – even before the van Eycks' *Ghent Altar* (ills. pp. 66, 67).

Whereas Jan van Eyck was preoccupied above all with surfaces, Rogier, in this respect more Italian, was interested in structures. As if inspired by fragile marionettes, what is so surprising about Rogier's figures is their – for a Netherlandish artist – astonishingly harmonious proportions and the flexibility of their individual limbs. Whatever other changes might be made, the layout of his *Descent*, the pose of his *Mary Magdalene* and the head type of his *St John* would remain constants until well into the latter phase of the school.

Paradoxically, it was precisely this underdeveloped capacity for free, independent observation and the corresponding perpetuation of long-established formulae from one generation to the next which, along with landscape and technique, met with interest in the South. A decisive intermediary role was played in this context by northern woodcuts and copperplate engravings, which like the paintings themselves

1350 — Parchment is increasingly replaced by paper.

1360 — The intellectual ideal of Humanism, based on classical writers, emerges in Italy.

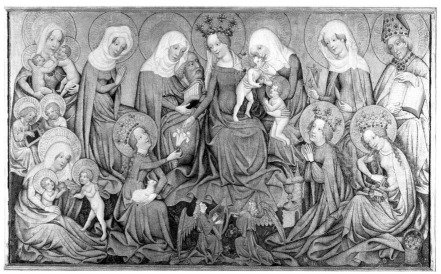

were distinguished by their extraordinarily high standard of execution. This made them sought-after collector's items which, in contrast to panel paintings, could transport new compositional solutions smoothly and quickly over hundreds of miles.

This time it was Germany which assumed a leading role. Here the genre was carried to its greatest heights by four artists in particular: Master E.S. (active c. 1450 – c. 1467), Martin Schongauer (c. 1435/50–1491; ill. p. 95), Israhel van Meckenem (active c. 1457 – c. 1465/70) and Albrecht Dürer (1471–1528; ill. p. 25), in whose work Raphael was also interested. Schongauer's engravings enjoyed particularly wide distribution, travelling as far as the Iberian peninsula – one of them is supposed to have been coloured by none less than Michelangelo. Dürer, meanwhile, would make up for his disappointment at being unable to study under Schongauer in person by becoming an avid collector of the works he left behind. Schongauer played an important intermediary role, too, having at one stage possibly been active in Rogier's workshop. The impact of his own art made itself felt in the Netherlands, where artists produced paintings which can only be described as colour versions of Schongauer's copper engravings – and this on occasions only months after the originals were first printed. The same was true in Spain, where they were similarly copied by Bartolomé Bermejo (c. 1430 – after 1498; ill. p. 24) and Fernando Gallego (c. 1440 – c. 1507).

The van Eycks, and many other later Early Netherlandish artists, too, remained indebted to the Middle Ages not just in their working methods. For all the verism they achieved in individual heads, they simply replaced the broad-foreheaded faces of the period around 1400 with their own ideal of an elongated oval. One stylization thus replaced another – thanks not least to Rogier, the master of the type.

In other respects, too, until far into the 16th century the only corrections being made were minor adjustments, rather than fundamental changes to composition, proportion, the human figure, draperies or landscape. The innovations being pioneered south of the Alps found their way at best into subsidiary details. Even the tracery, crockets and finials of Gothic decoration remained fundamental not just to architecture but also to goldsmiths, sculptors and painters.

In complete contrast to developments in Italy, this led in most cases to an even greater proliferation of the old forms, to greater overloading rather than greater simplicity. The Netherlandish, German and Spanish artists were so immersed in the formulae of the past that, even when they adopted a Renaissance motif for a capital, frieze or gable, the composition, proportion and structure of the building or furnishing in question remained entirely beholden to the Gothic style. At the same time, and again in contrast to Italy, virtually no new pictorial genres were evolving. Although the individual portrait was becoming increasingly popular, production continued to be dominated by religious subjects.

For all the brilliance of colour, for all the delights of the pictorial surface, however, supremacy continued to lie with two-dimensional line, as can be seen particularly from the few preparatory drawings that survive from the 15th century. The drawings executed directly on the panel itself, as visible today either through the fading glazes above them or with the help of infra-red light, concentrate primarily upon the detailed positioning of the draperies. Whereas heads, hands and elements of landscape are indicated for the most part with the most fleeting of strokes, the contours of drapery folds are precisely laid down and their hollows shaded with generous hatching. The only thing that changed after 1400 with the van Eycks and Campin was the style of these folds: softly undulating hems now gave way to sharp fissures.

1370 — Flanders becomes the centre of the European textile industry. **1378 — The Vatican becomes the residence of the popes.**
1381 — Following her victory over Genoa, Venice enjoys a flowering of trade, industry, scholarship and the arts.

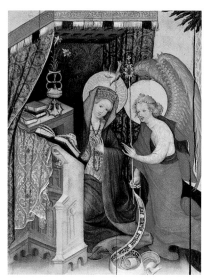

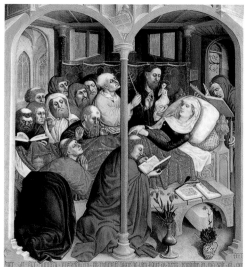

21 22

Whereas the painters of the International Gothic had indulged their love of line in the billowing draperies which enfolded their figures, these had now dropped flat to the ground, lying like a front garden at their wearer's feet and gridded with clearly ridged folds.

The Ghent Altar *Annunciation* (ills. pp. 66, 67) can be seen as highly typical of this trend, although it was by no means restricted to kneeling or seated figures. The two Ghent figures are typical in another respect, too. Their draperies are intended to look unstudied, but in truth nothing has been left to chance. In the case of the Virgin, the effect is achieved by the folds which fall first vertically downwards, and which then spill sharply sideways, in a slight overlapping of astonishingly smooth rectangular and trapezoidal planes. Almost more influential would be the numerous triangular forms making up the angel, who is lent additional relief by the wedge-shaped hollows in his robes. No less important than the folds themselves are the strong light and deep shadows which make them visible, and which give the draperies their powerful plasticity.

The style of an artist's drapery folds is thus the most reliable criterion by which to determine whether he had come under the spell of the Eyck revolution – more so than broader proportions, more individual faces or the "realistic" representation of plants and other details, aspects which depend more on the individuality of the artist and the subjectivity of the viewer. The impact of the Eycks' innovations upon their contemporaries must have been enormous. When a visit to an exhibition introduces us to a previously unknown direction in art, after leaving the museum we see our surroundings through the eyes of the artist we have just been viewing. The painters who were confronted by the inventions of the van Eycks could no longer see a face, a fold, a fruit tree or a sunset in the same way as before.

Within just five years of the completion of the *Ghent Altar*, outstanding representatives of this new direction in art had already emerged in various parts of southwest Germany. The *Magdalene Altar* by Lukas Moser (c. 1390 – after 1434) in Tiefenbronn (ill. p. 69) carries the same 1432 date as the van Eycks' own masterpiece, while the *Wurzach Altar* (ill. p. 20) by the Ulm artist Hans Multscher (c. 1390 – c. 1467) is dated 1437. The *Albrecht Altar* in Vienna must also have arisen around 1437, and the Rottweil artist Konrad Witz appears to have painted his great *Mirror of Salvation* altarpiece in Basle at about the same time. Six hundred miles further west, Nicolás Francés (c. 1434 – c. 1468) had already painted the high altar for León cathedral before 1434. They all feature the new realism, the heavy, massive forms and the heavy draperies falling in angular folds.

тhe waves of ɴetherlandish influence

This picture was consolidated over the following decades as "Netherlandizing" currents increasingly gained ground across Europe. In the 1440s, Barthélemy d'Eyck (doc. from 1444 – c. 1476) produced his famous *Annunciation* triptych for Aix cathedral (ill. p. 73), while in Naples Colantonio (doc. 1440–1465) made the new style his own. In Barcelona, Lluís Dalmau (doc. c. 1428–1461) set about painting, in his 1444/45 *Virgin of the Councillors* for Barcelona's town hall, one of the most faithful imitations of a van Eyck anywhere to be found. In Cologne, the most densely populated city in Germany, Stefan Lochner combined Eyck formulae with clear reminiscences of the Soft Style: the hems of the robes in his *Virgin of the Rose Garden* (ill. p. 77) undulate like waves. Particularly striking here, as in his Darmstadt

21. KONRAD OF SOEST

<u>Annunciation</u> from the Wildung Altar
1403, Mixed technique on wood, 79 x 56 cm
Bad Wildungen, St Nikolaus

22. HANS MULTSCHER

<u>Death of the Virgin</u> from the Wurzach Altar
1437, Mixed technique on wood, c. 150 x 140 cm
Berlin, Gemäldegalerie, Staatliche Museen zu
Berlin – Preussischer Kulturbesitz

23. STEFAN LOCHNER

<u>Annunciation</u> outer wings of the
Patron Saints of Cologne altarpiece
c. 1440–1445, Mixed technique on wood,
261 x 284 cm
Cologne Cathedral

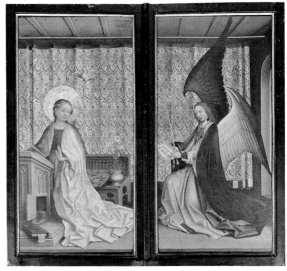

23

Presentation in the Temple, are the delicate, extraordinarily sophisticated harmonies of his palette. In the retrograde handling of scale in their figures, however, both panels lag far behind the van Eycks. Pasty, doll-like faces, overly large gold haloes and gilt grounds embossed with ornate decoration complete the picture.

That Lochner was nevertheless very familiar with developments in the Netherlands can be seen from the *Patron Saints of Cologne* altarpiece which he painted for the chapel in Cologne town hall, and which is today housed in Cologne cathedral (ill. p. 21). The folds here are far more angular than those of the *Virgin of the Rose Garden* executed a few years later. The *Annunciation* on the altar's exterior recalls the *Ghent Altar* even at the level of individual motifs in the Virgin's spreading draperies. In continuing to deploy elements from the past, however, Lochner was not betraying his incompetence, but was very consciously playing with the motifs and formal canons of different styles and regions – an "un-Gothic", extremely modern approach for which in the 15th century, significantly, parallels existed only in Italy. That we are dealing not with some inferior imitator, but rather with one of the most important Late Gothic artists of all, is surely demonstrated best of all by the fame which he enjoyed for generations to come. His design solutions and nature studies were drawn upon by Schongauer, himself a master of composition, and even Rogier van der Weyden, at that point the most important representative of the Early Netherlandish school. Over half a century after Lochner's death, Albrecht Dürer went to the chapel in Cologne town hall in order to admire for himself the masterpiece which still survives today.

It was precisely the freedom with which Lochner created his art that ensured he would remain an isolated phenomenon, however

famous. The Cologne painters of the following decades would orientate themselves towards their Netherlandish contemporaries, in the first instance primarily towards Rogier's "successor", Dieric Bouts (c. 1410/20–1475; ill. p. 82). Their borrowings were thereby restricted to selected figural, drapery and landscape forms. Their approach to composition and their techniques of preliminary drawing and execution remained entrenched in local tradition – not just with regards to such obvious features as gold grounds and nimbuses. A constant "updating" of forms derived from the Netherlands can be observed in other European regions, too. The latest trends in Bruges and Antwerp were still being adopted even in distant Portugal right up to the early years of the 16th century.

While painting in broad areas of Germany had been dominated in the 1460s by fairly similar "Netherlandizing" traits, towards the end of the 15th century artists in the south of the country increasingly began to emancipate themselves from such influences. Production flourished as private individuals and guilds competed with each other to crown all the main and subsidiary altars in their city and parish churches with altarpieces. Many cities saw the emergence of specialized workshops of high technical quality. Leading centres such as Vienna, Regensburg, Nuremberg, Augsbourg, Ulm, Nördlingen, Mainz and Colmar, not to mention Basle and above all Strasburg, became magnets for artists in their own right. They no longer needed to refer back to the Netherlands, particularly since Cologne lay much closer and the focus across Europe was now shifting towards Italy. Augsburg in particular began to orient itself increasingly towards the South.

1400 — Guilds achieve major influence throughout Europe. 1410 — Florence sees the Medici family rise to a position of dominance.
1412 — Filippo Brunelleschi discovers central perspective and thus influences the painting of the Renaissance.

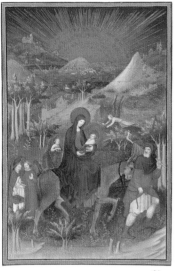

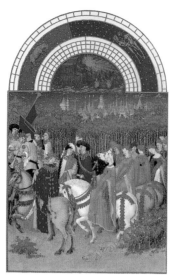

24. BOUCICAUT MASTER

Flight to Egypt fol. 90 v from
"Book of Hours of Marshal Boucicaut"
c. 1410–1412, Manuscript illumination,
27.5 x 19 cm
Paris, Musée Jacquemart-André

25. PAUL, JEAN AND HERMAN LIMBOURG

Calendar of the months: May
fol. 5 v from the "Très Riches Heures"
1414–1416, Manuscript illumination, 29 x 21 cm
Chantilly, Musée Condé (ms. 65)

26. AMBROGIO LORENZETTI

Life in the Country
from "The Effects of Good Government"
c. 1337–1340, Fresco (detail)
Siena, Palazzo Pubblico, Sala dei Nove

24 25

Training and workshop organization

As the nature of art production in the late Middle Ages implies, gifted apprentices could only realize their fullest potential within workshops of a correspondingly high standard and – also importantly – attracting a healthy volume of well-paying commissions. The notion of the self-taught artist was unthinkable; even in our own century, only a few such artists have reached the very top. The actual artistic style of the master remained of secondary concern, however. The importance of technical skills and the structure of urban society favoured the emergence of artist dynasties. Since the possibilities of setting up a new workshop were only limited, existing businesses were passed on if at all possible from father to son. Most artists acquired their basic knowledge of materials in their father's workshop. The majority of leading painters of the day were sons either of painters, such as Hans Holbein the Younger (1497/98–1543), or of goldsmiths, such as Schongauer and Dürer. Should a master die without leaving a direct heir, his workshop would usually pass, via marriage to his widow, to a particularly gifted pupil or senior journeyman – an arrangement which, in an age with no state welfare system, guaranteed both parties a necessary financial security. Within artisan circles just as between ruling houses, marriages were organized with practical interests in mind – even in this regard, the contrast with the modern image of the bohemian artist could hardly be greater.

In view of all this, it is hardly surprising that the three greatest artists of their day, Schongauer, Holbein the Younger and Dürer, should have grown up in the major centres of Colmar, Basle and Nuremberg. The decision whether to join a town guild, rigid in structure but guaranteeing a secure livelihood, or to try one's luck as an itinerant artist, which carried the possibility of earning far greater sums at some courts even without a master's qualification, was one that every artist then had to make for himself. Schongauer and Dürer remained faithful to the cities of their birth – notwithstanding Dürer's travels and occasional commissions for the aristocracy.

Despite the rigidity of the guild system, around 1500 the rivalry between the prosperous centres of southern Germany led to the emergence of prominent individuals within the arts. Appreciation of personal styles was growing, as can be seen in certain regions of Italy, even if the lead was being taken by the nobility rather than the civic authorities. Fussy collectors valued originality more than did conservative city notables. Names such as Marco Zoppo (c. 1432–1478), Andrea Mantegna (1431–1506) and Cosmè Tura (1429/30–1495) stand for this new attitude towards the artist, which comes closer to the modern concept of the genius. In the Netherlands, Hugo van der Goes represents an astonishingly similar trend.

An artist's social standing varied considerably even between one German city and another, and in particular between the North and Italy. Just how early on the Italian painters had risen above the status of pure artisans can be seen from the fact that we know almost all the leading artists of the 14th century by name. While Giorgio Vasari and other early writers on art played their part in this, they themselves lived over 200 years after Giotto and had to rely upon earlier records. They were thereby helped by signatures, which artists in the North were much slower to employ. Although isolated names are known to us from the 14th century (Theoderic, Bertram), the majority of artists – including many of the most prominent – remained nameless even in the final phase of Early Netherlandish painting in the early 16th century.

1422 — In the Netherlands panel painting develops from craft traditions.

1429 — Joan of Arc liberates Orleans and achieves the coronation of Charles VII in Rheims as king of all of France.

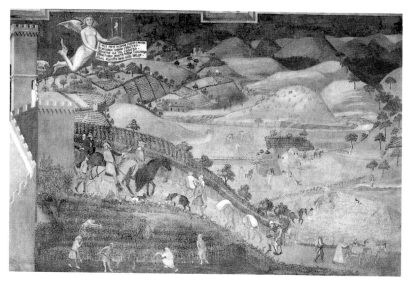

26

In order to distinguish between these anonymous artists, about a century ago makeshift names were invented for them, inspired either by the characteristics (Master of the Fat [Christ] Child) or, more commonly, the subject (Master of the Life of Mary), patron (Boucicaut Master), location, original location or even previous owner (Master of the Pollinger Panels) of particularly important works. Even amongst museum curators, there is a tendency to choose works by known masters over those by anonymous artists – something for which the works themselves give not the slightest grounds. Without the Boucicaut Master (active 1405–1420; ill. p. 22) or the Master of the Rohan Book of Hours (active c. 1420–1430), the history of French painting could not be written, nor that of Bohemia without the painter of the *Glatz Madonna* (ill. p. 43), the Master of Hohenfurth or the Master of Wittingau (ill. p. 53).

subjects of Gothic art

An overview of Gothic painting will inevitably be dominated by religious, and specifically Christian, art – not just because the term Gothic was originally associated with French cathedrals, but because the Christian faith infused, at least outwardly, many areas of life and above all death in every stratum of society that could afford art. In almost every culture in the history of humankind, the incomprehensible power of death has prompted people to spend more on the apotheosis of their own person or that of a dear one, and on the hope of a life after death, than on any other genre of art. Even more importantly, the paintings that resulted have survived longer than the decorative artefacts with which they brightened up their daily lives. Many apparently

"ordinary" altarpieces were intended by their donors to help ensure the salvation of their souls. The great scholar Nicholas of Cusa (1401–1464) was not the only one to have himself buried directly in front of the altarpiece which he commissioned. As over a hundred years earlier in the *Glatz Madonna* (ill. p. 43), the inclusion of his portrait as a figure in prayer ensured that he would be perpetuated for ever in the act of devout worship.

Secular painting concentrated upon the decoration of civic spaces and, increasingly towards the end of the Gothic era, upon the portrait, at first solely those of rulers (ills. pp. 46, 47), but subsequently also the private portrait. Even in manuscript illumination, non-religious illustrations remained in the minority. Alongside high art, which was only accessible to a very small section of society, there were undoubtedly other forms of art circulating amongst a much wider public. Considerably fewer of these have survived into the present, however, and the ones that have are much less differentiated in style. This not only makes it harder to date them, but makes it almost impossible to use them as a basis upon which to trace the development of Gothic art. Works of art which were not destined solely for the uppermost echelons of society are represented within these pages in the guise of some of the wall and panel paintings from Scandinavia and Spain.

In view of this concentration upon religious art, it follows that the majority of the works described here are altarpieces. Most are panel paintings, in other words paintings on wood, a medium employed since the late 12th century and in some places still in use even in Baroque times. At first they were hung as an antependium in front of the altar table, while the priest stood behind it and celebrated facing the congregation – a custom which was reinstated after the Second Vati-

1435 — Leon Battista Alberti writes his work "On Painting", in which he sets out the principles of perspective and anatomy.

1441 — Cosimo de Medici founds the first public library of San Marco in Florence.

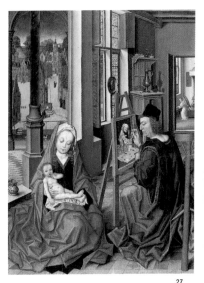

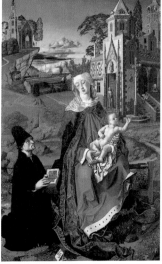

"A good painter is inwardly full of figures … and if it were possible for him to live forever, he would yet always have something new to paint."

Albrecht Dürer

27

28

can Council of the years 1962–1965. In the 13th century, following alterations to the liturgy still not fully explained or perhaps simply in line with changing tastes, the painted panels increasingly migrated up and onto the altar table, where they stood at the rear as a retabulum. This implies that the priest must now have been leading the service with his back to the congregation.

Within the altarpiece genre as a whole, a distinction may be made between the simple panel, or pala, which was the convention in Italy, and altars with – as a rule, folding – wings, as are found above all north of the Alps and the Pyrenees. These triptychs were only opened out on high days and holidays. The excitement of this moment was heightened for the faithful by the particularly opulent painting of their interiors, usually involving lavish quantities of gold. We occasionally find altars with double sets of wings, which can thus be displayed in three different ways. This concept of opening out may in part derive both from the idea and the physical shape of the containers used to house relics.

In Italy and Spain, on the other hand, rigid structures remained overwhelmingly, if not exclusively, the norm, although this did not necessarily preclude them from employing more than one section. Panels of different sizes were combined into larger superstructures, which in Spain and Portugal could extend to fill virtually the entire space behind the altar right up to the ceiling and out to the side walls. Like triptychs in the North, they frequently incorporated sculptures at their centre. These were elaborately painted in techniques similar to those employed for the panels, and were often admired even more greatly than the paintings themselves.

It is clear even from this brief overview that the Gothic panel painting needs to be considered in its original context, namely inside a church, on an altar table, perhaps topped by further panels and even, in

some cases, accompanied by holy relics and a donor's tomb. In their relief patterning and lavish use of gold leaf, the earliest examples of such paintings offer parallels with works executed by goldsmiths, such as caskets made to house the bones of saints venerated at the altar. The new genre of paintings destined for collectors and galleries was one that only began to emerge right at the end of the Gothic era. It would subsequently remain the norm until the gradual dissolution of the traditional forms of art in the 20th century.

Paintings on a textile backing are similarly only found in larger numbers as from around 1500. Over the following years they would become increasingly widespread, not least because of the lower costs involved. The use of less durable paint materials and a less thorough preparation of the ground meant they deteriorated easily. They were also treated with less care, since their value was considered to be lower. It was precisely this perception of canvas as having a lower worth that meant it was selected only rarely before 1500 for important works of art. The potential of the new medium only began to be recognized by painters such as Dürer. Unfortunately, many such paintings have suffered irreparable damage even in recent times as a result of inappropriate treatment. Specifically, canvases do not tolerate the protective coatings of varnish which have been applied, often thoughtlessly, in the modern museums of the 19th and 20th centuries.

In Italian art from Giotto to Raphael, wall painting is at least as important as panel painting. In contrast to the murals surviving in smaller numbers in the North, in which the pigments bound in oil or egg tempera were generally applied directly on top of a dry ground, artists in Italy mostly employed the true fresco technique. Fresco means fresh: the pictures were painted on plaster that was still damp, in sections which had to be completed at one stretch, with only gold accents

1455 — Flanders becomes the focus of European commerce. significance of the sciences.

1460 — Italian Humanism debates the essence and 1465 — Birth of the leading European Humanist Erasmus of Rotterdam.

27. DIERIC BAEGERT

St Luke Painting the Virgin
c. 1485, Mixed technique on wood, 113 x 82 cm
Münster, Westfälisches Landesmuseum für Kunst
und Kulturgeschichte

28. BARTOLOMÉ BERMEJO

The Virgin of Montserrat central panel of a triptych
c. 1482–1485, Mixed technique on wood
Acqui Terme, cathedral sacristy

29. ALBRECHT DÜRER

Lamentation of Christ devotional panel
for Margreth Glimm
1500/01, Mixed technique on spruce,
151.9 x 121.6 cm
Munich, Bayerische Staatsgemäldesammlungen,
Alte Pinakothek

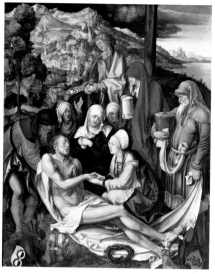

29

and a few other colours being added later. The possibility for cor-
rections was only limited, and thus the painting of vast surfaces such
as those confronting Andrea da Firenze (doc. from 1343 – after 1377)
in Santa Maria Novella – the mural he painted (ill. p. 51) was executed
in 156 different sections – demanded very precise preliminary studies
and a highly efficient and concentrated organization of labour. Out-
side Italy and the Alps, however, the frescoed interior of Wienhausen
monastery church from the years around 1355 and the few other
remnants which survive can only hint at the role which murals played in
the North. Façade paintings such as those still visible in a number of
southern German and Alpine regions must also have commanded a
more prominent presence in daily life than devotional panels.

To restrict this study to the genres of wall and panel painting
would be to do an injustice to the very artists who stood at their fore.
From Simone Martini to Martorell and Jan van Eyck, all also turned
their hand to designs for stained-glass windows, tapestries, and the
illumination of manuscripts. Following the destruction of so many
altarpieces, in many regions stained glass and manuscript illumina-
tions remain the only witnesses to artistic developments. Manuscripts
also have the advantage of facing a much lower risk of subsequent
deliberate damage, overpainting, restoration or fading, so that as a rule
they convey the artist's original intentions much more directly than
panel paintings or murals. Alongside a number of miniatures, the pres-
ent volume also includes examples of stained glass and unusual paint-
ings such as the Hildesheim ceiling.

Finally, it must be remembered that medieval painters were
employed in another, important sphere of art of which practically noth-
ing survives. Even in the accounts of the leading Gothic masters, more
receipts have survived which refer to the painting of banners, stan-
dards, steeple balls, festival decorations and the like than for the pro-
duction of art works in the modern sense. The raising, off Stockholm,
of the warship Wasa, built a century after the end of the Gothic era,
has given us an insight into the numbers of woodcarvers and painters
who would have been employed on "artefacts" of this type. In those
days there were hundreds of such ships, albeit only a few of such mag-
nificence.

In order to appreciate the significance of such decorative art for
the aesthetic of the Middle Ages, we need only consider the impact
upon our own daily lives of film sets and design, and how much more
strongly these affect us than the works of contemporary artists. Pop
artists such as Andy Warhol, Robert Rauschenberg and Jasper Johns
have not been the only ones to reflect this everyday aesthetic; although
the impermanent art forms of the Middle Ages are almost entirely lost,
the miniatures by the Boucicaut Master and the Limburg brothers
(ill. p. 22) suggest that their influence was already strong. Bearing all
these factors in mind, the scattered remains that are brought together
within these pages can nevertheless offer a colourful and many-sided
picture of the Gothic age in art.

Robert Suckale is the author of the extended captions on the
following pages: 30–39, 44–47, 52–61 and 68/69.

Matthias Weniger wrote the introduction and the extended
captions on the following pages: 26–29, 40–43, 48–51, 62–65, 72/
73, 76/77, 80/81, 88–91 and 94/95.

Manfred Wundram is the author of the extended captions on the
following pages: 70/71, 74/75, 78/79, 82–87 and 93/94.

1470 — The Portuguese discover the Gold Coast in West Africa.
1474 — Isabella I of Castile and Ferdinand V of Aragon marry to form a Spanish national state.

Embalming of the Body of Christ and The Three Marys at the Empty Tomb

Manuscript illumination, 30.4 x 20.4 cm
Chantilly, Musée Condé

So-called after the psalter of Queen Ingeborg of France, second wife of King Philippe Auguste. Ingeborg, who came from Denmark, was disowned by her husband. They were reconciled in 1213, and the psalter was probably a conciliatory gift. The workshop was active in Paris and comprises two principal painters and several assistants. The two painters, both of equal quality, also illuminated other manuscripts, sometimes together and sometimes alone, mainly for the court. As well as being thoroughly familiar with Byzantine art, they were probably in touch with contemporary manuscript illumination from northern France and England. They must also have known the works of the Meuse goldsmith Nicholas of Verdun (c. 1130 – after 1205). The miniatures appear as a complete series of pictures before the actual psalter itself, and without reference to the text, with two double pages of illuminations followed by two blank ones.

The magnificent psalter commissioned for the private use of Queen Ingeborg, probably by her husband Philippe Auguste, is the most important French illuminated manuscript to survive from the 13th century. At the time the psalter was executed, the sculpture cycle at Chartres cathedral was well on the way to completion and that of Rheims already begun, and the west portals of Notre-Dame in Paris were being built. Its compositions and many of its motifs nevertheless follow the Byzantine tradition, as represented by the great mosaic cycles in Sicily, for example, while the gold ground and the border look ahead to later 13th-century developments.

The Paris artist restricts himself to the generally muted colours of Eastern art. In imitation of classical models, however, he moderates the severity of his forms through the use of more softly moulded draperies, without thereby reverting to earlier, ornamental styles. The figures are shown in calm poses even in the most dramatic situations. The picture is kept two-dimensional and provided with the barest of backgrounds. The figures remain the yardstick, obscuring unimportant details. Their severity and dignity recall the greater monumentality being sought by contemporary sculptors. In embracing such a style, however, the workshop would also have reflected the tastes of the French royal court.

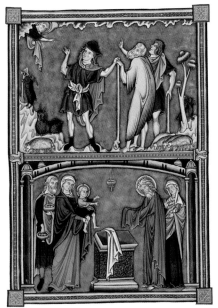

Events from the Life of Christ, c. 1200

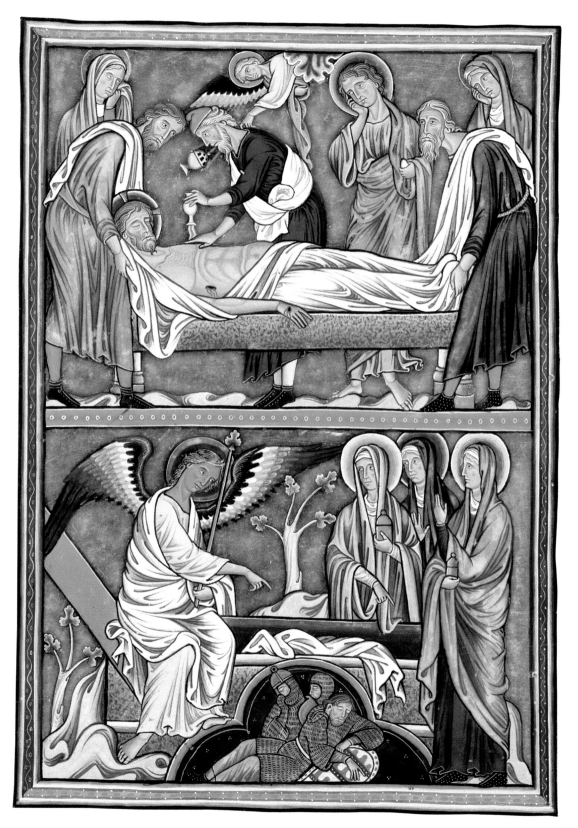

тhe Good samaritan and Genesis

Stained-glass window from the southern side aisle of the nave
Chartres, Notre-Dame cathedral

The master who was responsible for several stained-glass windows in the southern side aisle of the nave in Chartres cathedral cannot be pinned down in the shape of a single artist. Rather, the windows can be assumed to represent the combined efforts of a large workshop, which may perhaps be traced back to earlier works in Laon cathedral.

Few visitors to France's 13th-century cathedrals are aware of the complex religious programmes which lie hidden in each pane of their colourful windows. As in the illuminated manuscripts of the same era, so-called typological schemes were particularly popular. These juxtaposed episodes from the Old Testament with the events in the New Testament which, as "types", they foreshadowed. This concept lay at the heart of the artistic programme governing the side aisles at Chartres: the north-facing windows, which lie in the shade, are dominated by episodes from the Old Testament, in which God reveals himself to Israel. The windows on the south side, on the other hand, are devoted to the themes of resurrection and salvation.

Our detail is taken from a lancet window and is related to the overall programme in a particularly subtle theological way. The fact that its two subjects are not separated as clearly as in the typological window in Bourges is precisely what allows them to mirror each other in all the more sophisticated ways. Starting from the donors portrayed at the base of the window, the painting leads via the parable of the Good Samaritan to the Fall and the Expulsion from Paradise to, at the apex, Christ in Glory: the journey thus leads from Creation to the end of the salvation story. According to the parable, it was the Samaritan of all people, as a member of a despised minority, who went to the aid of a man attacked by robbers, after priests and Levites had passed him by. Since late antiquity, the traveller had been understood as sinful humankind, while the Samaritan stood for Christ himself. Consequently he wears a nimbus containing a cross. Christ was also the New Adam, who through his death on the Cross expiated the sins of the first Adam.

In his nakedness, Adam anticipates the state of the stripped and robbed traveller. In the central quatrefoil the two stories intersect. Above the picture of the traveller being looked after at the inn, we see Adam seated in Paradise in a scene devoid, astonishingly, of all narrative detail. To the left we see the creation of the first man, and on the right the creation of Eve from Adam's rib. The Creator, too, wears a nimbus containing a cross – representations of God the Father and Christ were often not clearly differentiated in this period. In the top lobe of the quatrefoil, we see God warning Adam and Eve not to eat of the Tree of Knowledge. This is followed in the three fields above by their disobeying his command and, in consequence, their expulsion from Paradise. Satan has assumed the shape of the snake, just as humankind's sins took the form of the traveller.

Beneath the central quatrefoil we see the Samaritan tending the wounded traveller at the side of the road and transporting him to the inn on his mount. As in the case of the only slightly earlier Hildesheim ceiling, red and blue grounds underlie the compositions.

"colour is the beauty of light, which is embodied in the material from which the creatures of the world are made. Beauty is also the harmonious design of these creatures, the exact proportion of their limbs, the geometric eurhythmics which can be expressed in figures."

Rosario Assunto

maestà di santa τrinità

Tempera on wood, 385 x 223 cm
Florence, Galleria degli Uffizi

* c. 1240 Florence (?)
† 1302 Florence

Cimabue (doc. 1272–1302) was the most famous painter of his generation. As one of the first great Tuscan painters, he executed commissions far beyond the bounds of his native Florence, such as the large fresco cycles in the Upper and Lower Churches of St Francis in Assisi, stained glass for Siena cathedral, mosaics for Pisa cathedral, and work for ecclesiastical patrons in Rome. He evidently had a large, well-organized workshop, one of the first of its kind in 14th-century Tuscany; it is probably where Giotto trained. His stylistic characteristics, as evidenced by his panel paintings, include a generosity and clarity of form, a restriction of colour to just a few, usually somewhat schematically distributed tones applied in flat planes, a precise delineation of outline, but a summary execution of detail. Cimabue soon found himself rivalled by the young Sienese artist Duccio. His Santa Trinità *Maestà* probably represents his response to this new challenge.

This Madonna was originally an altarpiece, at that time a new type of commission, but one which rapidly became popular. The presence of Christ evoked by the painting was intended to make the sacrifice of the Mass appear more concrete and at the same time to reinforce the divine authority of the priest reading the Mass.

The painter was required to create a work which combined solemn, monumental effect with an image that was easy to read. The plinth-like arrangement of the prophets indicates that, both chronologically and theologically, they provide the steps which lead up to Mary

and Christ. Their banderoles refer to Mary's virginity and Christ's role as Saviour. The organization of the painting, with its central emphasis, symmetry and balanced sides, is beautifully clear. The artist only deviates from this order in the figure of the Virgin, who is seen at a slight angle and who thereby focuses more attention upon her son.

The composition of the painting is clear and simple, the drawing precise. The seated and standing poses are nevertheless strangely removed from reality and lack tectonic cohesion. The individual motifs betray Byzantine sources. Apparent in the execution are certain traits of the fresco painter, with little attention paid to finer details. The panel has been unanimously attributed to Cimabue ever since its first mention by Vasari (1568).

Madonna and Child Enthroned with Angels and Prophets (Maestà), after 1285

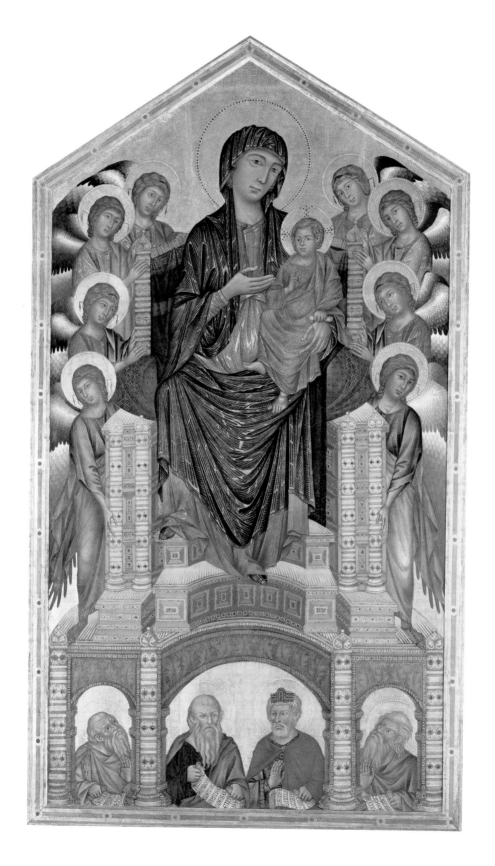

Enthroned Madonna with saints (Ognissanti Madonna)

Tempera on wood, 325 x 204 cm
Florence, Galleria degli Uffizi

*** c. 1267 Colle di Vespignano (near Florence), † 1337 Florence**

According to legend he was discovered by Cimabue as a boy, sketching his father's sheep. Although he was indeed a pupil of Cimabue, he worked more or less independently within his workshop, as evidenced by a number of frescos in the Upper Church in Assisi, which are attributed to him with great certainty. Impressed by the classical art to be seen in Rome, and by French sculpture and the Tuscan sculptors Giovanni Pisano and Arnolfo di Cambio, he developed his own, innovative style – one which nevertheless defies explanation in terms of other influences. Documentary sources tell us that Giotto was the most famous painter of his generation in Italy. His services were engaged by numerous high officials and princes, including the Pope and his cardinals for works in Bologna and Rome, King Robert of Anjou for large cycles in Naples, and the Scaligeri in Verona and Visconti in Milan. All these works, including large secular cycles, are lost. Of his late work, only some badly preserved frescos in side chapels of Santa Croce in Florence survive in outline. Giotto was an excellent organizer. He had a large workshop with a great number of well-trained assistants, so that he was in a position to undertake even the largest of commissions.

Towards the end of his life he was appointed chief architect of the city of Florence. Although this was little more than a title, Giotto does seem to have tried his hand at architecture.

This panel by Giotto, which hangs in the same room as Cimabue's painting (ill. p. 31), clearly demonstrates the distance separating Giotto from all that had gone before. Giotto's painting, perhaps just twenty years younger, has the same function and subject as Cimabue's, is almost the same size and employs a similarly symmetrical composition. There is a greater three-dimensional conviction to Giotto's throne, however: it has not descended from Heaven – as Cimabue unconvincingly attempts to portray it – but rests on two stone steps decorated with slabs of marble and colourful inlay. It is roofed by an ornamental canopy in Gothic forms which replaces an architectural setting. The steps serve to raise up the Madonna as a plinth elevates a statue, and also to create an empty space at the bottom of the composition corresponding to the area obscured by the officiating priest and the altar cross. The accompanying figures are crowded into the sides of the painting, their heads lower than that of the Child. All eyes are turned towards the Virgin, with a reverence further heightened by the introduction of two kneeling angels in the foreground. She alone looks out of the picture at the worshipper/viewer; it is to her that we must turn. Mary's role as intercessor is thus more clearly illustrated here than in Cimabue. The weight of her seated body is palpable, even as she draws herself up and presents her son. She is indeed the Seat of Wisdom. Giotto does not pattern her robes with the gold weave of Byzantine fabrics, the formula conventionally used to identify heavenly beings; nor does he employ colours solely of diamond-like purity and sumptuousness, but includes broken tones, as seen in the green of the angels standing on either side. His palette thereby appears to belong more to this world (the blue of the Virgin's mantle has greatly deepened and is too flat). Dress is portrayed just as it would appear in real life. In line with 13th-century sculpture, however, it nevertheless also serves a compositional purpose: the clear silhouette of the Madonna's cloak emphasizes the block-like nature of the central group. Its width reinforces the Virgin's monumentality, while the folds of the drapery lend her structure and guide the viewer's gaze to the infant Christ. Giotto portrays the Virgin by selecting the most dignified and beautiful of human features and heightening them to a sublime degree. Even so, the Madonna does not seem alien. Instead, she is a vision of regal grandeur.

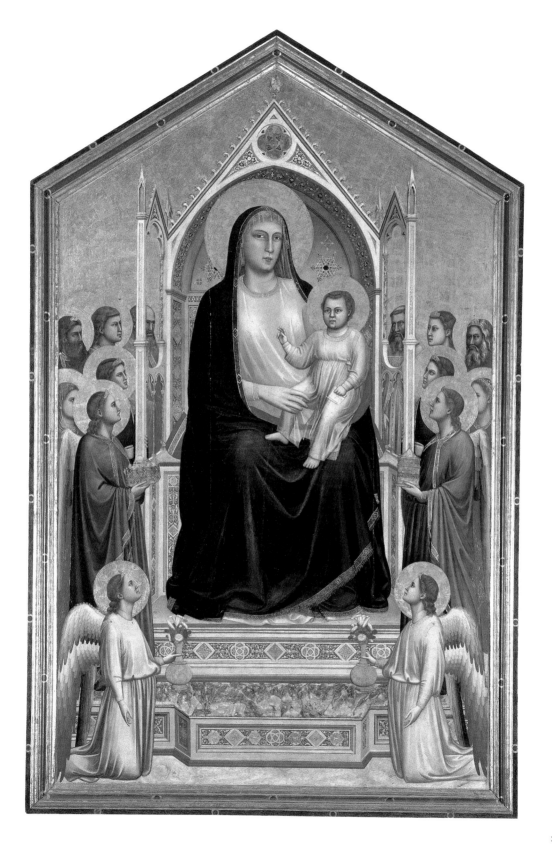

Peter's First Denial of Christ and Christ Before the High Priest Annas

Tempera on wood, 99 x 53.5 cm
Siena, Museo dell'Opera del Duomo

Duccio is first mentioned in 1278 in connection with minor commissions such as the decoration of book covers. His first authenticated masterpiece is the *Rucellai Madonna* in the Uffizi, which he executed for the chapel of the Laudesi confraternity in the Dominican church of Santa Maria Novella in Florence. While Duccio was probably seeking to compete with Cimabue, the painting also confirmed his importance as an artist even before the advent of Giotto – and in Florence, the bitter rival of Duccio's native Siena. Alongside smaller paintings, chiefly devotional panels, Duccio's greatest masterpiece is his *Maestà* (Virgin in Majesty) for the high altar of Siena cathedral. Duccio's painting reflects a profound and intensive study of Byzantine art, which then became a springboard for his own individual style. He remained very open to contemporary developments in art, represented above all by the sculptors of the Siena cathedral pulpit, Nic-colò and Giovanni Pisano. Their stylistic proximity to classical and Gothic sculpture, coupled with their vehement expressiveness, prompted Duccio to rethink many Byzantine formulae. He exercised great influence in his own day; he left behind him a prosperous workshop with painters who perpetuated his style. Unlike Giotto and the Florentine painters, he had a stimulating rather than stultifying effect on the younger generation of Sienese painters such as Simone Martini and the Lorenzetti brothers.

What is surprising about this panel is the way in which Duccio has taken two separate events from the Bible (albeit unfolding in the same building) and made them into one picture. Above we see Christ before Annas, the high priest to whom he was taken after his arrest and who now seeks a reason to convict him. The scene shows Christ's interrogation and, more particularly, the false evidence being offered against him by different people. Below, in what is presented as the courtyard of the high priest's palace, Peter is seated in a circle of the priest's men, warming his feet at the fire. Viewers contemplating the rear of Duccio's Maestà would have known, from the order of the pictures, to read the panel from bottom to top. They would thus have understood the *Denial* as the first scene and *Christ Before the High Priest Annas* as the second. This sequence is affirmed both by the figure of the servant girl, seen from behind in the act of turning to mount the stairs, and by the stairs themselves. Indeed, the pose of the girl is a stroke of artistic genius. Her outstretched arm may be understood both as gripping the railing and as pointing at Peter. Her isolated position at the left-hand edge of the composition immediately identifies her as playing an explanatory role, yet one who is not amongst the main characters.

A rich network of relationships is woven between the lower and the upper scenes, partly through analogy and partly through contrast. The spatial relationship between the servant girl and Peter is similar to that between Annas and Christ. The theme introduced in the lower half is taken up and amplified above: Christ stands alone in front of the soldiers, distinguished from them by his dress. Peter, on the other hand, has mingled with Annas' men and is hard to pick out from the group. He is sitting down and taking it easy, warming his feet by the fire, while his similarly barefoot master suffers. Whereas the figures in the lower scene form an almost complete circle, those above are presented more frontally. The architecture below is portrayed in some detail and includes a succession of receding planes, whereas the events above take place parallel to the pictorial plane, on a shallow stage with fake architecture. The ceiling lines vanish towards the centre, emphasizing Christ. There are many more such comparisons to be made, but we should mention in particular the intensification of colour which accompanies the progression from bottom to top, not just in the main characters. A striking feature from an art-historical point of view is the fact that the panel combines design principles which we would normally date to different epochs. Thus the flatter, symmetrical upper scene would usually be considered older, and the more plastic lower scene, with its greater spatial depth reminiscent of Giotto, more recent. Duccio here employs both in order to distinguish the solemnity and importance of the events.

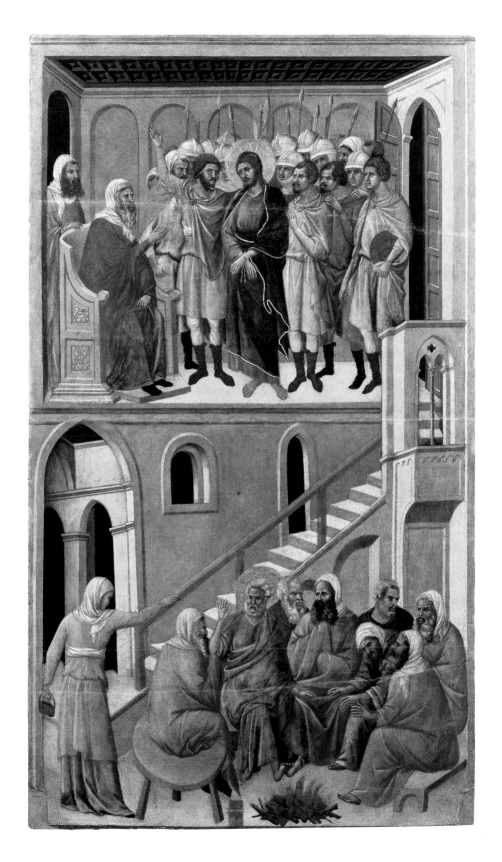

st martin is dubbed a knight musicians

Fresco, 265 x 200 cm (total size)
Assisi, Lower Church of St Francis

* c. 1284 Siena
† 1344 Avignon

Simone's projected date of birth is based on a 16th-century source, but may well be accurate, even though the date of his first signed work, the fresco of the *Maestà* in the Palazzo Pubblico in Siena, is a relatively late 1316. Such is his stylistic diversity that it has proved impossible so far to table a chronology of his works. It is not inconceivable, for example, that the *Maestà* in Siena, the devotional panels comprising the *Orsini Polyptych*, and the altarpieces in an old-fashioned style which he executed for Pisa and Orvieto, are all in fact contemporaneous. Whatever the case, Simone's works indicate that he had studied Duccio, Giotto and French art with the same intensity. He also drew inspiration from his sculptor colleagues, and in particular Giovanni Pisano. Even though this eclecticism is still detectable in the *Orsini Polyptych*, we can be certain that, by c. 1315, Simone must have already been a famous master. Otherwise it is most unlikely that he would have been awarded the *Maestà* commission in Siena. Nor would we find him, in 1317, being paid an astonishingly high salary in the service of Robert d'Anjou, who even raised him to the nobility. The Angevin kings of Naples and their supporters were his major patrons during these years. Together with his large workshop, he also worked for the city of Siena and various other clients in central Italy. Simone introduced some of the most significant innovations in the genre of the devotional panel, such as the so-called Madonna dell' Umiltá (Mary kneeling and at the same time suckling the Child). From 1339 at the latest he is documented in Avignon, where he worked for Cardinal Stefaneschi and other senior clergymen. While he left a school of followers both in Siena and Avignon, some of his achievements became the common property of all 14th-century art. Already highly praised in his lifetime – including by Petrarch, for whom he executed several works – his fame lived on not only in Siena, where in the early 15th century he was considered the greatest Sienese painter of all, but also, for a long time, north of the Alps.

The decoration of the Lower Church in Assisi was funded by a donation from a Franciscan cardinal who died in 1312. The cardinal had been an ardent supporter of the house of Anjou, in whose service he had helped with the acquisition of Hungary. The cycle comprises ten scenes from the life of St Martin, starting with the episode in which he divides his cloak with the beggar and finishing with his death. Despite its church setting, the cycle is a work of court art; painted by Simone Martini, himself ennobled while in Anjou service, it glorifies the French ruling house through the figure of St Martin, who was both French and Hungarian. It thereby gave implicit blessing to French dominion over the kingdom of Hungary and lent support to the Anjou party all over Italy and in its struggle for the imperial crown. But while the episode in which St Martin is dubbed a knight belongs to the chivalric and secular world, not so the style of Simone's painting.

Although the detail reproduced here shows a group of musicians – their faces by no means noble – in colourful dress, they are fully absorbed in their music-making. This is particularly true of the singers. The severity of the line, the stylization, and the limited scope of movement and space within Simone's composition distance the scene from the viewer. The fresco is recognizably the work of a panel painter. Simone's attempt to create an iridescent effect by superimposing two different colours within the brim of the recorder-players's hat, and his focus upon fine details, show him applying the techniques of panel painting to the medium of fresco.

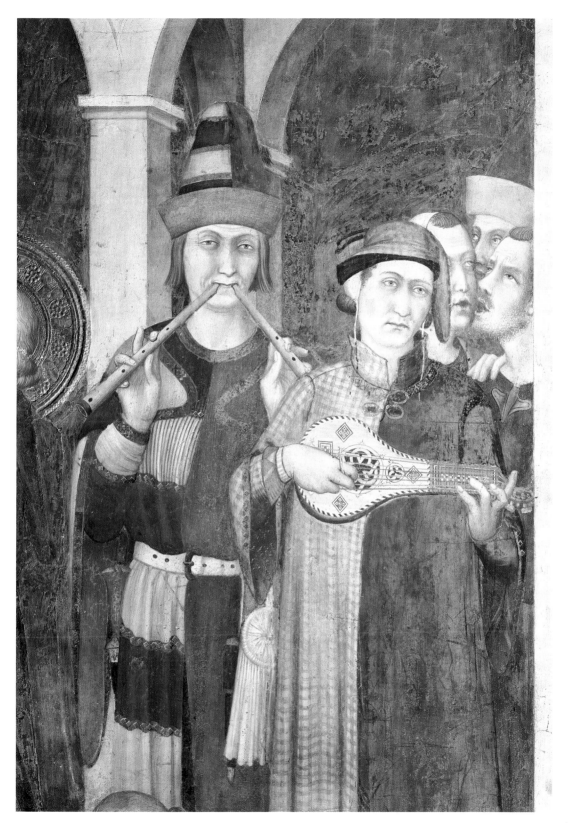

The Effects of Good government

Fresco (detail), 296 x 1398 cm (total size)
Siena, Palazzo Pubblico, Sala dei Nove

* c. 1290 Siena (?)
† c. 1348 Siena (?)

Ambrogio was probably the younger brother of Pietro Lorenzetti and certainly came from the same artistic background. Ambrogio, who is documented as living in Siena from 1319 to 1347, paid at least two lengthy visits to Florence. This may explain his detailed knowledge not just of the painting of Giotto, but also that of his Florentine successors. It may explain, too, the influence of Sienese art upon Florence, and particularly upon the genre of the small-scale devotional picture. In the thoroughness with which he established space and depth, he was the most modern master of the 14th century. Noteworthy, as in the case of his brother, is his faithful observation of nature, and even more so the assurance and lightness with which he portrays movement and life, rhythm and emotion. While the mood in Pietro's painting tends towards sombreness, Ambrogio creates a more cheerful, more relaxed, richer atmosphere.

We tend to see Gothic art as something reserved exclusively for churches, and there can be no doubt that the development of new artistic techniques and media was primarily fuelled by ecclesiastical commissions. There is nevertheless evidence that a large and important body of secular art was also created between the 13th and 15th centuries. Historical sources document commissions for paintings, almost none of which have survived into the present. Examples include portraits of traitors, debtors and political opponents, often suspended by their legs in disgrace. Large fresco cycles were also common both in city palaces and in houses. In the sphere of secular art, every change in ruler, in party and even in day-to-day politics (such as a switch of allegiance) threatened any paintings created to champion the ideas and teachings of those previously in power. In short, secular art was destroyed more thoroughly than religious art. This is why the present set of frescos, located in Siena's Town Hall, are so precious.

At the time when they were painted, Siena had a republican constitution, but was *de facto* an oligarchy controlled by the merchant classes. Lorenzetti's frescos adorned the Sala dei Nove, the council chamber housing the meetings of the so-called "Nine", Siena's highest decision-making body. Since members of the public were probably admitted to the chamber at times, the cycle would also have served as a form of propaganda. The scenes illustrated here form part of a comprehensive intellectual programme expressed in artistic (allegorical) terms.

The central theme is stated on the end wall opposite the window. The large figure right of centre is the personification of Good Government, representing both the city of Siena and the public weal. On the far left we see Justice with her scales, guided by Wisdom *(Sapientia)* above. To her right is Concordia, who holds a rope in a play upon her name (*corda* = rope). This rope is held by the 24 city councillors below, some of them clearly portraits. Lorenzetti has orchestrated the cycle in such a way that, upon entering the chamber, the spectator is presented first with the gruesome personifications of Bad Government, and then, on turning to the right, with the figure of Justice as its counterpart. The procession of city councillors then leads the eye to the main group composed of Good Government and the cardinal virtues. The right-hand wall bears the large fresco of *The Effects of Good Government*. Lorenzetti's cycle should be read not simply horizontally from left to right, however, but also vertically, and above all with regard to its intellectual axes. One such axis can be identified on the *Good Government* wall in the classical-style figure of Peace *(Pax)* portrayed in a semi-reclining pose between the personifications of Justice and Good Government. Not without reason is this room frequently referred to in older sources as the Peace Chamber.

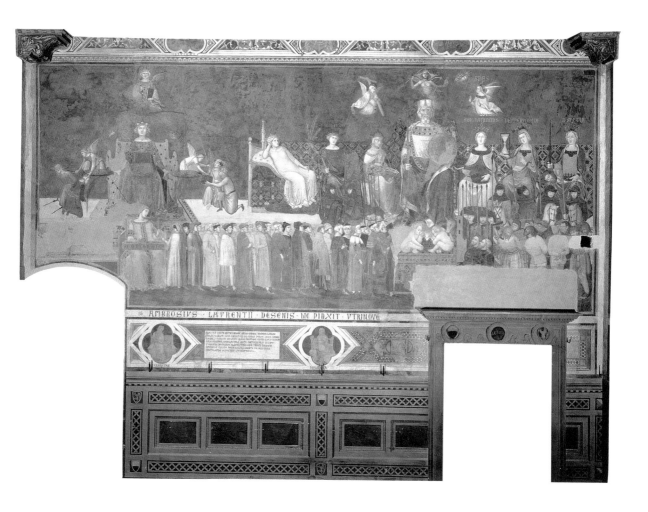

Fishing

Al secco painting and fresco
Avignon, Papal Palace, north wall of the Deer Room in the Tour de la Garde-Robe

The chief surviving paintings by this workshop are the frescos of various hunting scenes which decorate the Deer Room in the Tour de la Garde-Robe, built in 1342/43 under Pope Clement VI, in the Papal Palace in Avignon. The style of the paintings suggests that they were designed by Italians, while their execution was probably entrusted to French assistants. The master in charge may possibly be identical with Matteo di Giovanetto da Viterbo, who was the current court painter to the Pope.

The "Babylonian exile" of the popes (1309–1376) transformed the previously somewhat insignificant city of Avignon into the most magnificent residence in Europe. A huge papal palace was built which was decorated by artists from Italy, and specifically Siena, with none less than Simone Martini at their head. The surviving murals convey a unique impression of a court of the day. The preference for motifs taken from the animal and plant kingdoms reaches its high point in the pope's favourite relaxation room, the Deer Room, a testament to the nobility's passion for hunting. It is the oldest representation of Nature on such a grand scale, of such ambition, and with such fidelity to life.

Hunting with falcons, ferrets and decoy birds, and scenes of bathing and harvesting, are interwoven with individual trees and plants in a rich tapestry extending across all four walls. The only wall uninterrupted by doors or windows is dominated by a large pool rendered in a perspective fashion, around which various different means of fishing are portrayed. As in the case of the birds and plants, we are shown a wealth of different species of fish; there is even a dolphin. The choice of subject and its execution seem to reflect both French and Italian ideas, although the project would ultimately have been headed by an Italian.

Falconry, 1343

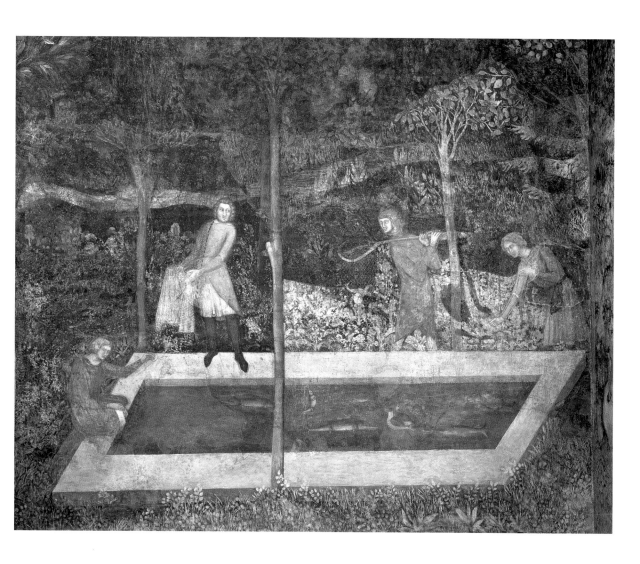

41

glatz madonna

Mixed technique on poplar, 186 x 95 cm
Berlin, Gemäldegalerie, Staatliche Museen zu Berlin – Preussischer Kulturbesitz

The anonymous master, named after the panel in Berlin, may equally well have come from Germany as from France or Bohemia. In the middle of the 14th century he headed a flourishing workshop in Prague. Together with pronounced influences from the art of the Italian Trecento, his paintings also reveal borrowings from the Rhineland. Stylistically related to the *Glatz Madonna* are the *Eichhorn Madonna* and a Madonna from Strahov monastery (Prague, Národni Galeri).

Historically, iconographically and in terms of its painting technique, the *Glatz Madonna* is a key work of the Bohemian school. It stems from the Silesian town of Glatz, now Ktodzko in Poland, which at the time it was painted belonged to the diocese of Prague. It was here that the donor Ernst of Pardubitz, later the first archbishop of Prague, spent part of his childhood, and it was in here, in 1364, that he would also be buried. According to a description of the painting dating from 1664, it at that time stood in the collegiate church which Ernst had founded when bishop, and was surrounded, in the Italian or Byzantine fashion, by a series of smaller paintings. Although the patriarchal cross hovering in front of Ernst was executed at an early stage of the painting, it was perhaps not planned right from the start. The painting can thus be dated fairly accurately to the period between 1343, when Ernst was made a bishop, and 1344, when Prague was elevated to an archbishopric.

The cloth of honour held up by two angels veils the traditional gold ground. The throne's architectural surround is treated as a real edifice: angels look out through windows with wooden shutters, or appear from beneath large semi-circular arches. Behind the apparently so playful, lovingly evoked details are concealed numerous Marian symbols. The lions are a reference to the throne of Solomon, the black wall in the lower section to Mary as a "garden enclosed", the wood of the back of the throne to the "cedars of Lebanon", and the star at the upper edge of the picture to Mary's honorary title "Star of the Sea".

The hymn of the same title was sung chiefly at the Feast of the Annunciation, on which Archbishop Ernst had been born and to which he dedicated his collegiate church in Glatz. Ernst himself had extolled King Charles IV as the new Solomon at the papal court in Avignon, which may also explain why Mary's regal dignity is so greatly emphasized in the Glatz painting. Corresponding to the idea of the throne of Solomon, too, is the Byzantine motif of the scroll in the hand of the infant Christ, who thereby appears as the "Word made flesh" as described in the Gospel of St John. Not even Mary's dark skin colour seems a coincidence. The bride in the Song of Songs was black, and the House of Luxembourg, from which Charles IV was descended, traced its origins back to the Biblical progenitor of all Africans. With his bishop's insignia laid down on the steps of the thone, Ernst presents himself as Mary's vassal and at the same time demonstrates his humility. The technique employed in the painting is as subtle as its content. The artist uses an oily binder which allows colours to melt into each other at their point of transition, as familiar from enamel. The luxurious oriental-style fabrics employed for the bishop, Child and canopy are portrayed with extreme sophistication. Shot with gold, they are of a type produced in Italy.

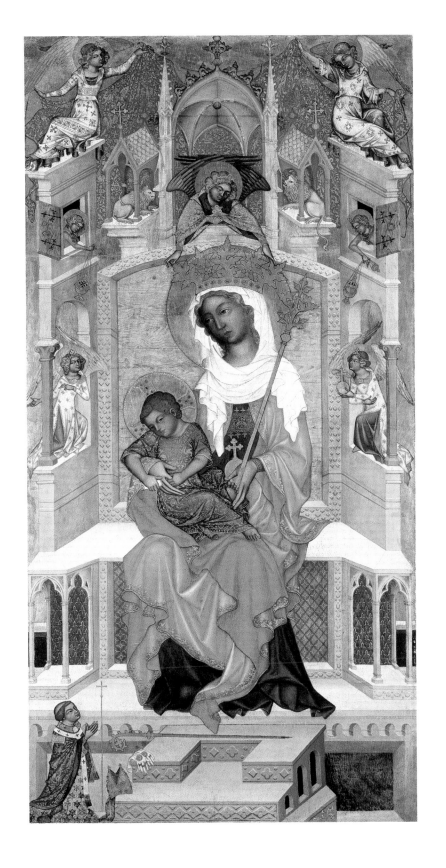

43

st Jerome

Tempera on wood, 113 x 105 cm
Prague, Národni Galeri (formerly in the Chapel of the Holy Cross, Karlstein castle)

Records of 1359 mention a house owned by Theoderic, painter to the emperor. Since he is later referred to as *familiaris*, Theoderic can be seen as closer than most artists to the court he served. In 1367 he was granted tax exemption for an estate in Morin which lay at the foot of Karlstein castle, and which had probably previously belonged to his predecessor at court, the Strasbourg painter Nikolaus Wurmser. This exemption from taxes was granted, it was explained, because Theoderic had created "skilful and solemn paintings" and had decorated the chapel in an "inventive (including in the technical sense) and ingenious" fashion. These words from the emperor's own lips were praise indeed. Yet it is unclear where Theoderic came from and where he trained. While Bohemian and Italian art form his starting-points, he

seems to have absorbed certain influences from the German art of the day, such as the sculpture of the Parler workshop, with its block-like character and monumental heaviness, which incorporates stylistic elements of 13th-century sculpture. Theoderic's art is in turn distinguished by its monumentality, its orientation towards the past, and its integration of various trends, including Italian, western European and Byzantine. In artistic terms, he thereby seems to have expressed precisely what the emperor wanted to say. From 1355 to 1375, painting in Bohemia was entirely under his sway.

This picture was originally painted for the Chapel of the Holy Cross in Karlstein castle, designated by Emperor Charles IV to house the imperial treasures, which included a large piece of the True Cross, the Holy Lance and the Holy Nail, and other holy relics of note. The gilt ceiling of the chapel was decorated with stars made out of gilded glass, representing Heaven, and with frescos. The walls were adorned with 133 panel paintings presenting a hierarchical "host" of saints. The impression of being not simply in front of a representation of Heaven, but of being in Heaven itself, was reinforced by the semi-precious stones studding the walls. 550 candles filled the dark chamber with light. Their flickering flames not only emphasized the glitter of the gilded décor but also made the colours sparkle. Within this chapel, so the emperor desired, the churches of Heaven and earth were to meet; it was to demonstrate both his imperial might and its divine legitimation. Master Theoderic, who played a major role in the decoration of the chapel, deliberately created the paintings as wall panels. In their restriction to head and hands, however, they also have something of an icon-like quality. They deliberately lack spatial depth. Their attributes, such as the book held by St Jerome in the present example, are disproportionately large. The saints portrayed were lent a potency above and beyond their artistic presence by the fact that each of their frames contained a relic associated with them.

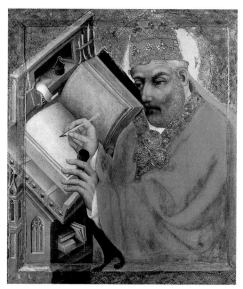

St Gregory, c. 1360–1365

Portrait of Duke Rudolf IV of Austria

Mixed technique on parchment mounted on spruce, 48.5 x 31 cm
Vienna, Erzbischöfliches Dom- und Diözesanmuseum

Stylistic analyses of the portrait of Rudolf IV have regularly spotlighted its links with the Prague court art of just a few years earlier, and with its leading protagonist, Master Theoderic. The Vienna painting also features other innovations derived from Bohemian painting. In view of the numerous artistic exchanges taking place between Bohemia and Austria, however, it is equally conceivable that the portrait was the work of an Austrian artist, whose style looks forward to the somewhat later Master of the Schloss Tirol.

Although this portrait was later hung near Rudolf's tomb, there is no reference to his death in the inscription. That it may have been commissioned by Rudolf himself is further indicated by the fact that he is portrayed as an archduke (*Archidux*, as the Latin inscription reads), a rank which Rudolf unlawfully awarded himself. Rudolf also had himself carved in stone in St Stephen's cathedral wearing the pointed archduke's hat, whose bow makes reference to the imperial crown. If the painting was indeed executed before 1365, it is the oldest autonomous portrait in the history of German art. It was admittedly intended less to capture an accurate likeness, however, than to reinforce Rudolf's political status. The shape of the bow evidently cites more or less exactly the bow in the crown of the Bohemian king Charles IV, whose daughter Catherine Rudolf married in 1357. The solidity of the areas of flesh contrasts abruptly with the treatment of the blonde hair and in particular the very two-dimensional portrayal of the serrated hat and the coat. The apparent lack of connection between the circlet and the bow has led some to conclude that the portrait was painted before the archduke's hat had actually been made. If this were the case, however, the portrait would have made no sense to Rudolf's contemporaries. Nor would such a theory explain why the painter also rendered the shoulder area flat, just like the hat.

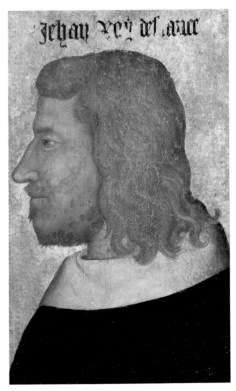

Girard d'Orléans, Portrait of John II "The Good", King of France, c. 1349

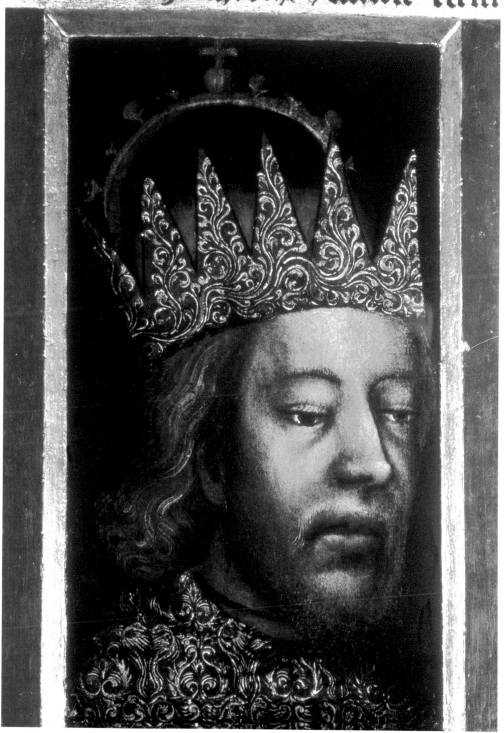

Triumph of the church

Fresco (detail)

Florence, Santa Maria Novella, Chiostro Verde, Cappellone degli Spagnoli

According to his entry in the records of the Florentine guild, Andrea was active as a painter and architect. It was in Florence that he executed, in 1365– 1367, his most important work, the fresco cycle in the chapter-house (known as the Spanish Chapel) of the Dominican priory of Santa Maria Novella. During this same period he was also involved in the planning of the dome for Florence cathedral. In 1368 he was active in Orvieto, but he is documented as being back in Florence in 1372 and 1374, first as representative of the guild of *Medici e Speciali*, then as a member of the Compagnia di S. Luca. Stylistically, he can be broadly termed a follower of Giotto, while also displaying Sienese influences. Hence some of his works have occasionally been attributed to the similarly oriented Andrea Orcagna. Around 1377 Andrea went to Pisa, where he frescoed the south wall of the Camposanto with scenes from the life of St Raniero.

The frescos decorating the chapter-house of Santa Maria Novella celebrate the Church and in particular the Dominican Order, whose brothers gathered within its walls. In the most famous fresco in the chapel, Dominic, the founder of the order, is portrayed as the intermediary between sinful Earth and Paradise. Standing almost exactly in the centre, his entire body points, like a human signpost, in the direction of salvation, towards St Peter, who guards the gate to Heaven. Confessing his sins at Dominic's feet is the donor, buried here in 1355. In the zone of Heaven, angels are gathered around the figure of Christ in Glory, enthroned on a rainbow. The fresco is dominated less by this aureole, however, than by the element to which it owes its particular fame: its astonishingly accurate side view of Florence cathedral, Santa Maria del Fiore, and its detached campanile, at that time only thirty years old. Andrea has thereby anticipated the completion of the cathedral – it would be more than fifty years before Brunelleschi's magnificent dome was actually finished. It is no coincidence that the souls in Paradise should stand on top of this real building, which serves as a symbol of the universal church. The vicars of Christ on earth have gathered in front of the cathedral, with the Pope at their centre. The guard dogs in front of him make a play upon the colours and name of the order (*domini canes* = dogs of the Lord).

Triumph of Saint Thomas Aquinas, c. 1367

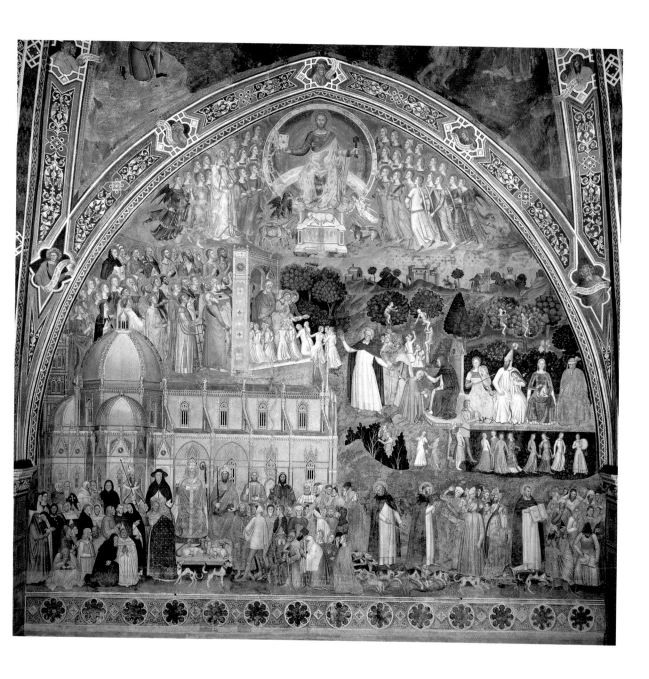

The creation of the Animals from the grabow Altar

Mixed technique on wood, 180 x 720 cm (total size)
Hamburg, Hamburger Kunsthalle (formerly in St Peter's church, Hamburg)

Precisely where this important painter and possibly also wood-carver was trained remains a matter of dispute. His artistic roots appear to lie in Westphalia and northern Germany, and above all in the Bohemian painting of the Prague court, but he also draws upon the French miniatures of such as Jean Bondol. Bertram is first documented in the Hanseatic city of Hamburg in 1367. He subsequently rose to become not just the leading master in Hamburg, but indeed one of the most important artists in northern Germany as a whole. In c. 1380 he executed his most important work, the high altar retable for St Peter's church in Hamburg. In 1383 Bertram is mentioned as owning a piece of land in the city; further sources indicate that he must have run a large workshop. In 1390 he drew up his first will, in which he also speaks of a planned pilgrimage to Rome. A second will of 1400 mentions a daughter, Gesa, and his brother Curd von Byrde. In 1414/15 Bertram and his wife Grete are recorded as deceased members of the Confraternity of the Holy Cross of St John. In addition to his *St Peter Altar*, Bertram is attributed with a *Passion Altar* (Hanover, Niedersächsisches Landesmuseum), two panels in Paris and an *Apocalypse Altar* in London.

On the former high altar of St Peter's church in Hamburg stood one of the largest, most important and, in terms of its content, most complex altarpieces to survive from the 14th century. In 1731 large parts of it reached Grabow in Mecklenburg, from where they only made their way back to Hamburg at the beginning of this century. The date 1379 can be found in the shrine; according to Hamburg records from the 16th century, the altar was "made" in 1383. As in many comparable altarpieces, a *Coronation of the Virgin* originally stood in the centre of the carved interior. It was framed by the figures of 44 saints arranged on two levels. When the inner of the double set of wings was closed, the viewer was presented with 24 fields of equal size, of which no less than 14 relate, in highly unusual detail, the story of Creation right up to Cain's murder of his brother Abel. These are followed by four Old Testament scenes, leaving just six for the childhood of Christ.

The fourth to sixth fields depict the creation of the plants, the animals and man, whereby the compositions make reference to one another. The figure of God in the fifth, middle field appears between two vertical tiers of creatures. The mammals are assigned to a steep ledge on the left, while the birds are placed one above the other against the gold ground on the right, as if decorating the border of a page of manuscript. Bertram was more interested in the skilful organization of his pictorial fields than in narrative realism. The subtlety of his composition can be seen in the main figure: Bertram creates space for God's raised left hand by having him bend forward, while the arabesque cloth breaking out from the main body of his robes repeats the gesture of his right hand. Similarly ornately scrolling motifs determine the Creator's left side, heralding the cascading draperies of the International Gothic of the years around 1400.

Bertram makes no attempt to show the birds in flight. They are nevertheless observed with considerably greater accuracy than the large mammals, which are harder to identify. Their greater fidelity to nature, coupled with the fact that they give the impression of being cut out, suggests that Bertram was able to refer either to studies he had made himself or to specimen sheets of birds, such as are known to exist from this period. A particular role was played in this regard by painters of illuminated manuscripts – a genre in which Bertram was also active. Undoubtedly the easiest to study were the fish, especially for someone living in Hamburg, and indeed, they seem to be particularly close to life. Yet Bertram includes no contextual details of land or water. The ground itself nevertheless deserves particular attention. It is missing entirely from the scene of God separating the light from the darkness, perhaps because of the subject. From very abstract forms, Bertram moves towards ever more naturalistic grounds. His landscapes clearly reveal French influences, while his massive figures are derived from Master Theoderic.

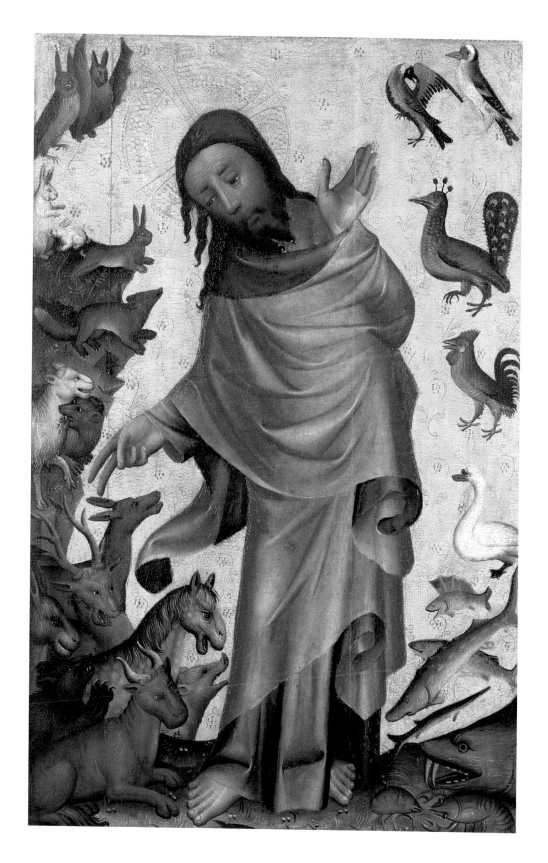

The Resurrection

Tempera on wood, 132 x 92 cm
Prague, Národni Galeri (formerly in the Augustinian Canons' church of St Aegidius)

We know nothing about this master, and have to deduce everything from his pictures. He was named after his principal work, the former altarpiece in the Augustinian Canons' church in Wittingau, now Třeboň, in southern Bohemia. Its high altar was consecrated in 1378; the altarpiece was perhaps already completed at this point, or finished soon afterwards. The Master of Wittingau must certainly have been active by no later than 1395, since the Jérén epitaph of this date makes clear stylistic references to his art. His paintings for Wittingau coincided with the reform of the monastery, in which the emperor played an active role. Hence, too, it is suspected that his workshop was in Prague, rather than in southern Bohemia. A Madonna panel from his workshop, which originated from Raudnitz, now Roudrice, north of Prague, seems to confirm this. The reconstruction of the altarpiece still presents problems. The two panels illustrated are from the weekday side of the altarpiece, as evidenced by the fact that the painter has used a red ground instead of gold. The master employed assistants on the *Wittingau Altar*. He had a large workshop and was extremely influential in his own day. We can only speculate about his artistic origins. He shows no evidence of any links with Italian art. His starting-point was undoubtedly older Bohemian painting. Thus the soldier on the left in *The Resurrection* cites the pose of the Child in the *Eichhorn Madonna*. His grasp of lighting can also be traced back to Master Theoderic. The Master of Wittingau may also have been influenced by Franco-Flemish panel painting, of which nothing now survives, and which we can only attempt to reconstruct from the – somewhat later – paintings of Broederlam. In his innovative interpretation of subject and composition, and above all as a colourist, the Master of Wittingau is outstanding amongst the artists of central Europe between 1350 and 1400.

The retable which once stood on the high altar of the Augustinian Canons' church in Třeboň today survives only in fragments. It is nevertheless clear that the two panels on this page, formerly visible on the weekday side of the altar, are the works of a master of European standing. The intensity with which the artist has re-thought and re-interpreted his subject is also clear in his *Resurrection*. The risen Christ has floated through and out of the closed and sealed tomb. We are shown not the moment of resurrection, but the state of being resurrected. The painter presents the event as a true miracle. The watchmen fix their eyes on the apparition as if entranced.

While *The Agony in the Garden* takes place in twilight, the light in the *Resurrection* is more vibrant. The painter displays a feel for the expressive powers of objects; never before have weapons appeared sharper or shields more spiked. But he has a feel, too, for beautiful rhythmical forms, as can be seen in the sequence of curves in Peter's robe. This delight in softly undulating lines is by no means in conflict with the artist's more profound approach to his theme. Studied in depth, these two panels yield a wealth of detail which extends not only to individual members of the natural world, such as the many birds, but to much more besides. Striking features include the looseness of the brushwork and the varying treatment of the surfaces. Helmets and nimbuses are painted in different layers of glaze, as if the artist was already acquainted with the techniques of oil painting. Effects of light and colour are richly graded. Looking closely, too, we can see that the artist has frequently deviated from his own preliminary sketches, scored into the ground and still clearly visible. It is evident that this painter, even as he established the types which others would copy, did not approach his composition with fixed ideas, but continued to rework his subject even in the final stages of execution. A notable exception is the figure of the resurrected Christ, in which he clearly cites an older, more static and two-dimensional type in the manner of the Master of the Hohenfurth *Crucifixion*.

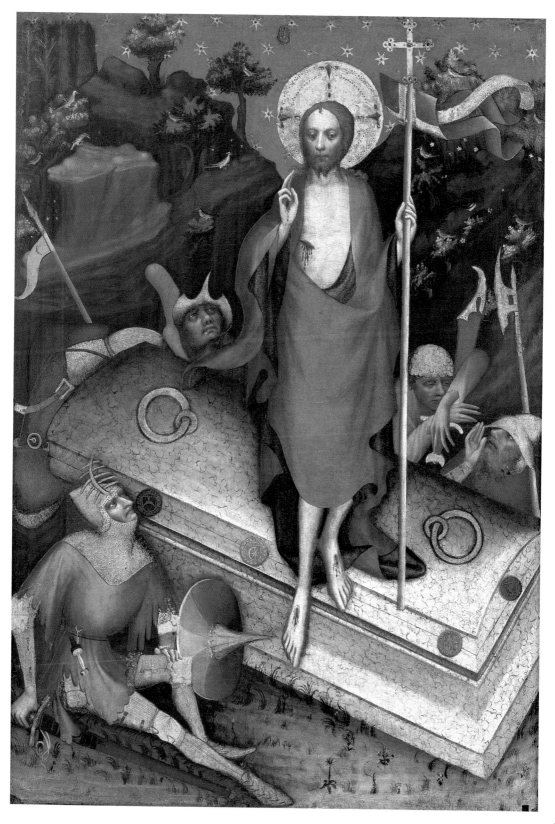

virgin and child with eleven angels

Tempera on wood, 45.7 x 29.2 cm
London, National Gallery

The unknown master of the Wilton Diptych was probably English, and active at the English court around the period 1380–1395. A painter in the International Gothic style, his name is derived from the fact that his diptych was formerly located at Wilton House, the seat of the Earl of Pembroke. This is the only work to have been attributed to him. His painting is distinguished by its delicate colours, its tendency towards an ornamental handling of line, and the precision of its ornamentation.

This is a more modern, more courtly form of the diptych. In the left-hand panel, King Richard II of England is being commended by his patron saints – Edward the Confessor, Edmund of East Anglia, and John the Baptist – to the Madonna and Child, seen surrounded by a ring of angels in the right-hand panel, and with whom he appears to enjoy almost equal status. The diptych thus serves both as a devotional painting and as a staged piece of self-promotion for the king. The reproduction opposite can convey only an imperfect idea of the painting's highly sophisticated technique. Thus, for example, a tiny picture of the British Isles with a white castle can be found on the globe above the flag. The flowers beneath the Virgin's feet are portrayed in the greatest of detail, as are the small stags on the angels' robes and the brocade patterns on the clothes worn by the aristocratic figures on the left, with their folds and other decorative features, in part embossed and engraved as well as painted. The diptych was probably executed by an English master, but one who was thoroughly acquainted with the art being practised at the French courts. He was clearly equally familiar with the Bohemian type of the beautiful Madonna – Richard II's first marriage had been to a Bohemian royal princess. A distinctive feature of this work in the aptly-named International Gothic style is its use of foreshortening, whereby the artist borrows Italian motifs in a demonstration of his virtuosity.

King Richard II of England (kneeling)
with his patron saints, c. 1395

"once more we see how the artist showed his skill in foreshortening, for instance in the posture of the angel kneeling on the left side of the panel, and how he enjoyed making use of studies from nature in the many flowers which adorn the paradise of his imagination."

Ernst H. Gombrich

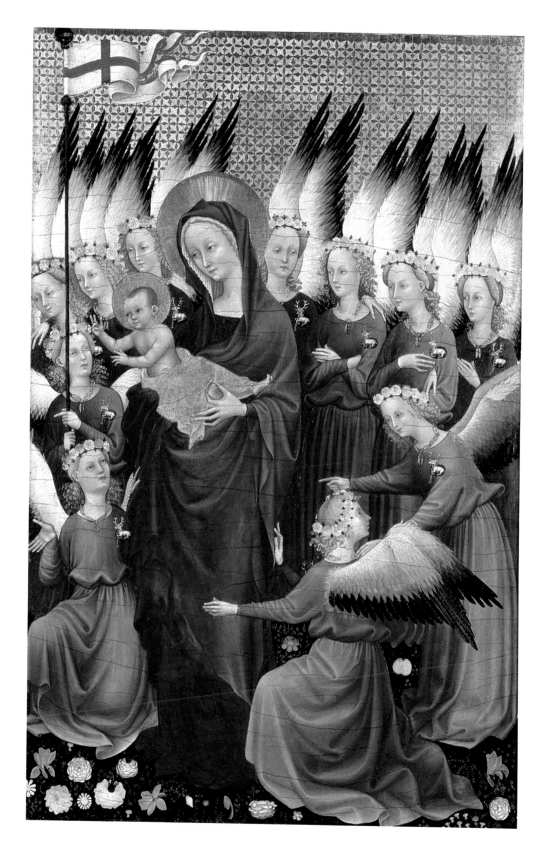

virgin in ʜortus conclusus with saints

Mixed technique on wood, 26.3 x 33.4 cm
Frankfurt am Main, Städelsches Kunstinstitut und Städtische Galerie

As a consequence of iconoclasm and the many wars in the region, very little Upper Rhenish painting has survived. What fragments do remain demonstrate very clearly, however, the important role played by the art of this region in the 14th and 15th centuries. During the first part of the 15th century, in particular, art production would have been given a significant boost by the Councils of Constance and Basle. Due to its affinity with other works of known provenance, such as the *Madonna of the Strawberries* in Solothurn, the *Paradise Garden* is undoubtedly a work of Upper Rhenish art. Whether it was painted in Strasbourg, Basle, Constance or somewhere else is harder to answer. Its style has its origins in the *Crucifixion* in Colmar Museum, which dates from 1410 and whose artist trained in Bruges, as corroborated by miniatures also from Bruges. This indirect link may explain the proximity of some of the motifs used in the *Paradise Garden* to the early works of the van Eyck brothers.

Perhaps intended for a canoness or abbess, this panel offers an original variation upon the theme of the Virgin of the Rose Garden. Although Mary, reading a book in the upper half of the picture, is recognizably the most important figure in the composition, contrary to the conventions of the day she is neither the central focus of events nor even the central axis of the composition. At her feet, St Catherine is playing with Christ; to her left, St Dorothy is picking cherries, and in the bottom left-hand corner St Barbara is ladling water out of the well. Seated on the right are St Michael, with the devil at his feet, and St George with a small dragon; the legendary figure of St Oswald is leaning against the trunk of the tree.

There is a deliberateness and reflectiveness to all the activities taking place. Nowhere is the tenderness of the mood disturbed. Our eye wanders across the picture, stopping to contemplate each figure and natural detail in isolation. The painting as a whole is infused with Marian symbolism: the enclosed garden protected within its solid walls is an image of Mary's intact virginity. At the same time, it establishes an internal frame within the composition. With its delight in details, this type of devotional painting renders harmless such elements as the dragon accompanying St George and opens the door to more subjective interpretations of traditional themes of painting.

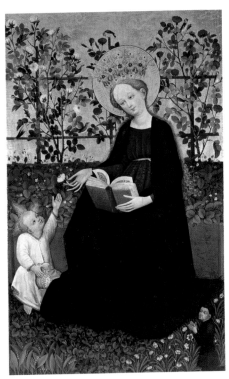

Madonna of the Strawberries, c. 1420

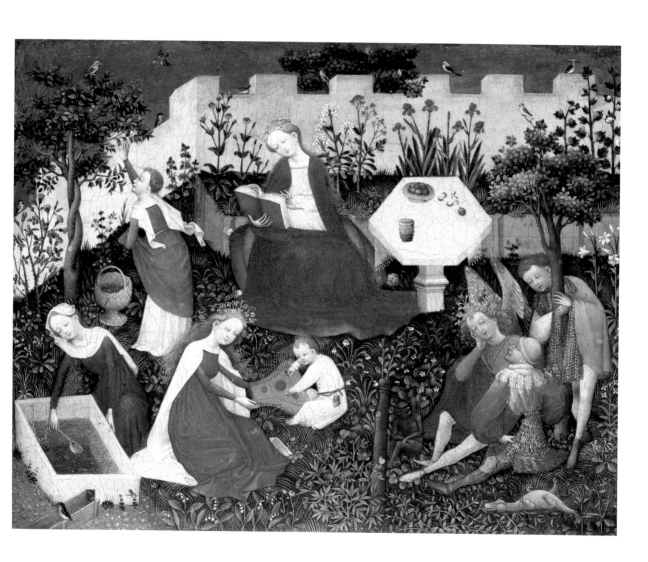

st veronica with the sudarium

Mixed technique on wood, covered with canvas, 78.1 x 48.2 cm
Munich, Bayerische Staatsgemäldesammlungen, Alte Pinakothek (formerly in St Severin, Cologne)

This artist, named after the panel today housed in Munich, is a particularly typical representative of Cologne painting from the years around 1400–1420. Since there seem to have been many other artists in Cologne working in a very similar style – a consequence partly of the weighty tradition of Cologne's own school of painting, and partly of the great influence which the Master of St Veronica exerted upon his colleagues – it is hard to determine the precise extent of his œuvre. The dating of individual panels also poses a problem, one that has yet to be convincingly resolved. The upheavals wrought by secularization erased their entire history – for not one of his paintings is dated, and in not one of them can we identify a donor, or even establish the painting's purpose, with complete certainty.

Veronica is a creation of legend. She arose out of the *vera icon*, the supposedly "true image" of Christ which variously took the form of panel paintings, shrouds (as in Turin) and painted cloths. The story of St Veronica is associated with one such piece of cloth, known as the sudarium. According to legend, Veronica offered Christ her veil as he passed her on the way to Calvary. After he had wiped his brow, his image remained miraculously imprinted upon it. The popularity of the subject in art was fuelled by the fact that the sudarium was one of the main objects of pilgrimages to Rome in the Middle Ages, and that veneration of such pictures earned many indulgences. Furthermore, many Christians hopefully believed that the vision of this miraculous picture warded off the threat of sudden death.

Thus the sudarium bearing the "true image" of Christ is both the real subject and the centre of this panel. The smaller figure of Veronica holds up the cloth with an expression of devotion. The two groups of small angels contemplate in the sudarium both the mystery and the entirety of the Passion. These angels are painted in the most delicate of colours and with a sophisticated technique, and testify to the great skill and sensitivity of the artist – something to which Goethe would draw admiring attention in 1815.

Calvary Hill (the so-called Small Calvary), c. 1415

"Because it unites in itself the dual element of an austere concept and an indulgent execution, the picture exerts an incredible force on the beholder, aided more than a little by the contrast of the frightful medusa-like face with the delicate virgin and the graceful children."

Johann Wolfgang von Goethe

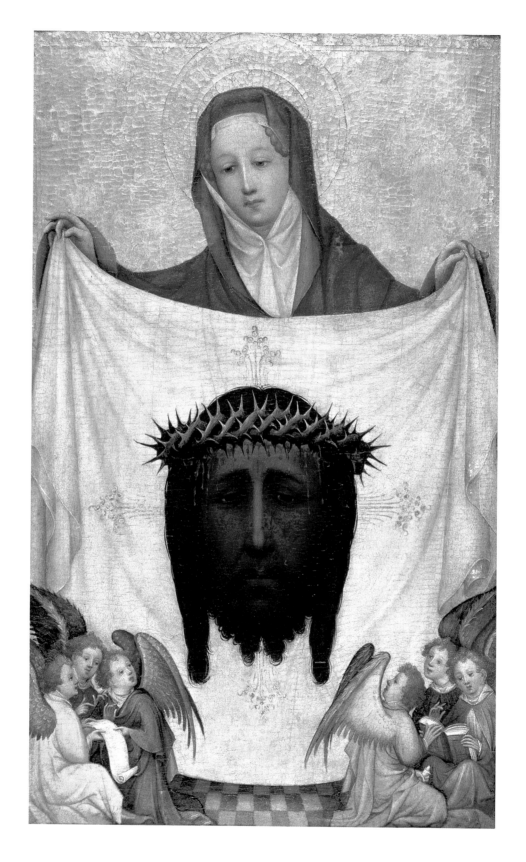

adoration of the magi

Tempera on wood, 144 x 177 cm
Florence, Galleria dell'Accademia

===

Lorenzo Monaco, who is documented as living in Florence between 1388 and 1422, was born in Siena in c. 1370. Of the Sienese painters, the most influential upon his work was Simone Martini, although the manner of his tonal sequences suggests that he also studied Pietro Lorenzetti. His early Florentine works reflect the style of Giotto's successors, such as Agnolo Gaddi. Even when these influences faded, he never returned to the strict two-dimensionality of older Sienese painting. In 1390 he entered the Camaldolensian monastery of Santa Maria degli Angeli in Florence. In 1402 he was admitted to the Florentine guild of painters. It seems that he left the closed monastic community at this time, but without giving up the

monkhood. In 1414 he rented a house near to, and owned by, the monastery. He executed a number of miniatures in the service of his order. No other painter of the period around 1400 in Florence went so far in their stylization of form and colour. Lorenzo thereby sometimes departed entirely from plausibility. But it would be unjust to call him a merely decorative artist, for he opened up new possibilities in the credible representation of the celestial and the visionary.

In the late 15th century, in keeping with the taste of the day, this panel was given a rectangular frame, while an Annunciation and prophets were added to its spandrels. It probably originally featured a predella. *The Adoration of the Magi* was at that time a very popular subject. The homage offered by the Three Kings, one from each of the three known continents and representing the three stages of man, to the "new-born King of the Jews" underlined Christ's status as the king of kings. Hence, too, the name Epiphany for the festival on 6 January (epiphany = the appearance of a divinity). The oldest king, Caspar, represents Asia, considered the noblest continent since it was here that Jerusalem, the centre of the world, was to be found. Caspar brings gold, a symbol of Christ's power. The second, middle-aged king, Melchior, symbolizes Europe and bears frankincense as a token of Christ's priesthood. Balthasar, the youngest, represents Africa and presents myrrh as a symbol of Christ's Passion and sacrifice on the cross.

In the years around 1400, this subject was prized as an opportunity to mount a display of courtly pomp, to paint a party of travellers, and also to portray exotic peoples in a fashion true to life. Thus the present panel includes Africans, Turks and Mongols each wearing their own distinctive dress and, in particular, striking hats. There is even a camel behind the mounted figures on the right. The composition incorporates several different moments in time: on the right, the figures are watching the star of Bethlehem, i.e. the comet, that led them to the stable, while in the middle and on the left we see the procession and the Adoration.

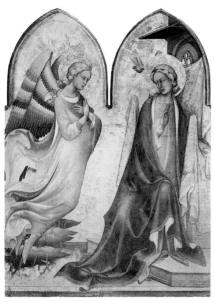

Annunciation, c. 1410–1415

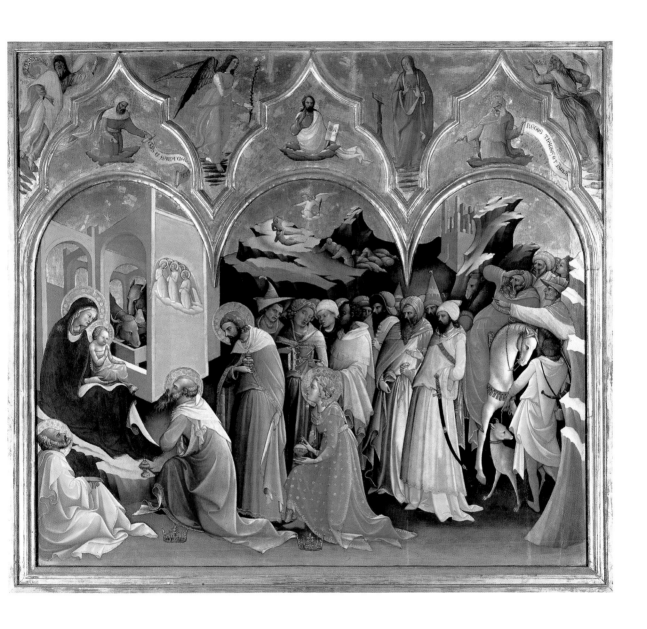

Nativity from the st Thomas à Becket Altar

Mixed technique on oak, 99 x 89 cm
Hamburg, Hamburger Kunsthalle

Francke seems to have come from a family of shoemakers who had moved to Hamburg from Zutphen in Gelderland. He is estimated to have been born around 1380, as he must have been several years younger than Konrad of Soest, who was one of his formative influences. Francke entered the Dominican priory of St John in Hamburg and was active as a painter there. This may have been why he did not have a large workshop of his own. Being a friar does not appear to have restricted his freedom of movement: his extensive knowledge of western European art must surely have been acquired over the course of several trips further afield. He was highly regarded by the Hamburg merchants, who supplied him liberally with commissions. We know that he also executed paintings for Reval (modern Tallinn) and the See of Münster. His influence was profound, and continued to work upon by other artists even into the 1460s. Unfortunately, the major part of his work was destroyed at the hands of iconoclasts during the Reformation.

The Miracle of the Wall, 1414

The surviving panels of the *St Thomas à Becket Altar* are characterized above all by the graphic vividness with which the soldiers are depicted, the barrenness of the rocky landscape, and the powerful overlapping with which Francke lends his narratives a whole new sense of drama. The red ground studded with gold stars is already familiar to us from the Master of Wittingau (ill. p. 53). As appropriate to its theme, the *Nativity* is the most lyrical and tender panel of the altar. Despite its gracefulness and its predominantly pale skin tone, typical of the day, Mary's head is relatively broad and heavy. Contributing in no small way to the popularity of the altar was the extraordinarily rich and gentle, almost park-like landscape present in the surviving panels; the foreground, however, is here sandy, bare and unwelcoming.

Did the Infant Christ not appear to be bedded in the rays of light emanating from him, and did the angel's luminous red wing not seem to shield him protectively? The fact that he is made to lie on the bare ground with not even a blanket to cover him would be all the more shocking. Master Franke thereby gives expression, for the first time in northern Germany, to an idea going back to the vision of St Bridget. The blue cloak which the three angels hold up like a fence around the Virgin is a very personal invention by Francke, and offers a rich opportunity for the overlappings which he loved so much. According to St Bridget, Mary took off her cloak in order to worship the Child in her white dress and with her hair uncovered. God the Father looks down from a corona of clouds, which are treated with remarkable animation for the time. With his hands raised in blessing, he alone is set against a gold background.

Nativity

Oil on oak, 85.7 x 72 cm
Dijon, Musée des Beaux-Arts

Recent research is more or less agreed that the artist who has long been known as the Master of Flémalle (after a triptych thought to have come from Flémalle Abbey near Liège, and today in the Städelsches Kunstinstitut in Frankfurt) can be identified as Robert Campin. The issue is not altogether resolved, however, since although Campin is documented in records on numerous occasions, he has left no signed works. Some have tried to equate him with the young Rogier van der Weyden, but for all that they had stylistically in common, their differences remain such that they seem more likely to have enjoyed a teacher-pupil relationship.

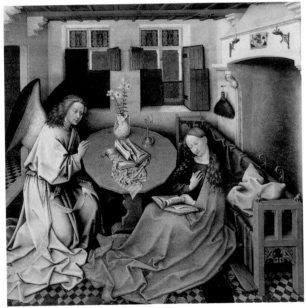

Annunciation, not dated

Campin was born around 1380 in Tournai, where he qualified as a master in 1406/07 and was probably Rogier's teacher from 1427 to 1432. Together with the van Eyck brothers, he may be considered the founder of the Netherlandish painting of the Early Renaissance. While the influence of the Limburg brothers and Burgundian court art can still be felt in his early work (*Betrothal of the Virgin and Annunciation*, Madrid, Prado, c. 1410), he soon turned to three-dimensional figure representation and the exploration of depth (*Nativity*, Dijon, c. 1425–1430). These reach a climax in Campin's late works, in which the painter becomes almost obsessed with perspective (e. g. the *Mérode Altar*, called after its original location, now in New York, Metropolitan Museum, c. 1430, and the *Werl Altar*, Madrid, Prado, 1438).

This portrayal of the Holy Family once again follows the vision of St Bridget. It also incorporates the story of the two midwives, towards one of whom the angel dressed in white is descending: her hand has been paralyzed as a consequence of her lack of faith, and can only be cured by the Infant looking at it. This somewhat frivolous embellishment of the story is not the only thing that separates this painting from the *Ghent Altar* (ill. p. 67) with which it is virtually contemporaneous. For all the richness of their apparel, its figures remain rather colourless and schematic. Their type-like faces lack the depth of expression found in the van Eyck brothers. The swathes of drapery veil the fact that the figures are not truly three-dimensional. Making up for these deficits is the setting. The painting is one of the first great landscapes of Western art. The artist shows us the defects in the stone, beams and wicker walls of the stable, the pollarded willows and little stream which border the track leading deep into the background – towards the comfortable inn, the splendid town, the expansive lake and the fantastical mountain peaks behind which the morning sun is rising. The rays of the sun are rendered in old-fashioned gold, which does not prevent them, however, from allowing the distant trees and passers-by to cast wonderfully observed shadows.

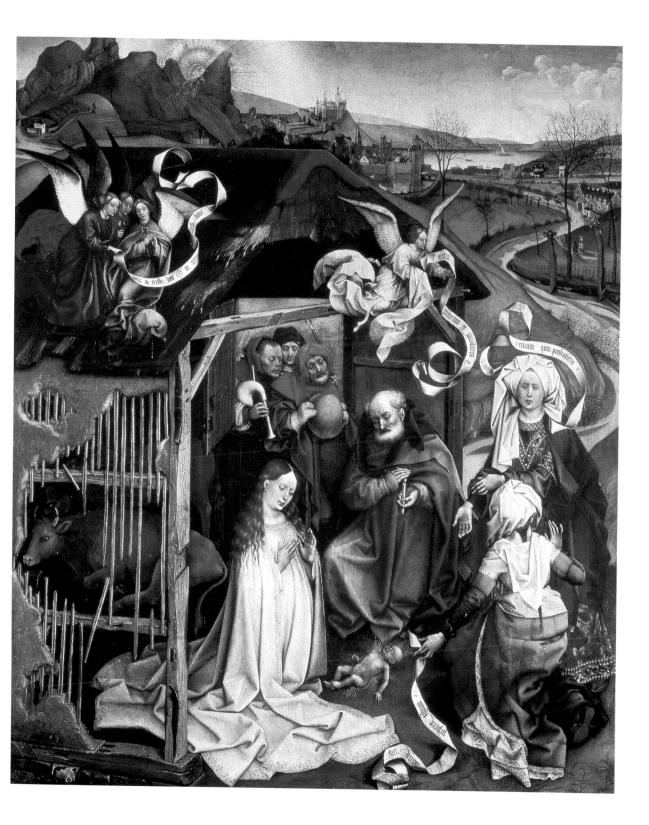

christ, virgin, John the Baptist and Adoration of the Lamb (Ghent Altar)

Oil on wood, each, 167 x 72 cm (above) and 134 x 237 cm (below)
Ghent, St Bavo

* c. 1390 Maaseyck (near Maastricht)
† 1441 Bruges

Jan van Eyck can claim to be as important for painting north of the Alps as Masaccio for Italian art. His portrayal of the human figure as a three-dimensional body, his portraiture in the modern sense, his minutely observed landscape, and his perspective construction of interiors combine to give a suggestion of reality which can only be described as "Renaissance" to distinguish it from medieval art. At the same time, van Eyck was the chief representative of a new chapter in the history of colour. Although he did not, as Vasari would have it, invent oil painting, he employed oil as a transparent binder. This allowed him to lay down a succession of translucent layers of paint (glazes) and thereby achieve an intensity and depth of colour never seen before. This technique particularly complements the portrayal of jewellery and costly fabrics, which attain an unparalleled degree of realism in his painting. Jan van Eyck's importance was recognized in his own day: until 1422 he was employed in the service of Duke John of Bavaria, for whose residence in The Hague he executed paintings no longer extant. He was subsequently employed at the court of Philip the Good of Burgundy, who entrusted him with various diplomatic missions – a sign of the high regard in which he was held. From about 1430 Jan van Eyck lived and worked in Bruges as painter to the court and the city. In 1432 he completed the *Ghent Altar*, which he had originally begun with his brother Hubert van Eyck, who is named first in its inscription. How much of the altar – the greatest work of Netherlandish painting of the first half of the 15th century – actually stems from Jan's hand remains a matter of dispute, since we have no au-

thenticated works by Hubert against which to compare it. As Hubert died in 1426, however, Jan must have worked alone on its execution for another six years.

The *Ghent Altar* represents the founding work of Netherlandish Early Renaissance painting. In its open position, the central section shows the approximately life-size figure of Christ (or God the Father?) between Mary, intercessor for humankind at the Last Judgement, and John. Underneath we see the inhabitants of the City of God adoring the Lamb. Common to all four panels are their exquisitely luminous colours and their painstaking reproduction of details – sumptuous robes, sparkling jewels, and individual facets of the landscape and architecture. In terms of its artistic qualities, the *Ghent Altar* is without rival in painting around 1430.

The altarpiece is unusual, however, in its arrangement of large single figures above a scene smaller in scale and of much greater complexity. Equally surprising is the contrast between the setting in the upper three panels – restricted to a tiled floor – and the sweeping landscape below. Have two different projects here been combined into a single altarpiece? Has the uncertainty surrounding the identity of the central enthroned figure (Christ or God the Father?) in fact arisen out of the belated superimposition of the Holy Ghost and God the Father above the Lamb (i.e. Christ), lending the whole the nature of a Trinity?

> "within twenty years the human spirit, as embodied in these two men, has found in painting the ideal expression of its faith, the characteristic expression of the faces, … the first and most precise depiction of the body in its exact forms."
>
> Eugène Fromentin

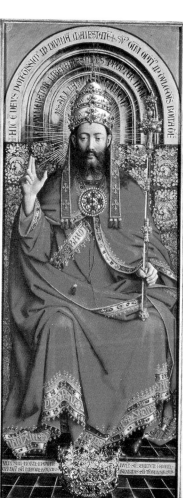
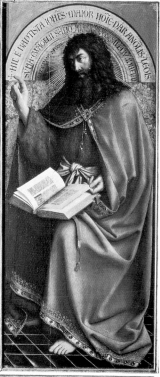
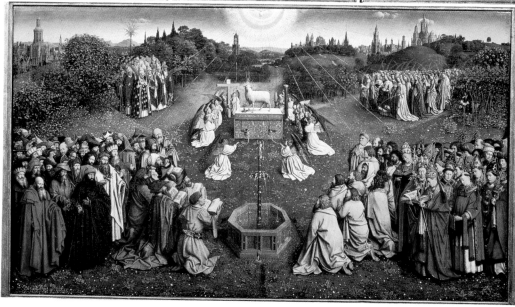

magdalene Altar

Mixed technique on wood, c. 300 x 240 cm
Tiefenbronn, St Mary Magdalene

Lukas Moser (doc. 1419– 1434) was born in Weil der Stadt near Stuttgart, but probably worked mostly in Ulm, where he also produced designs for stained glass. Moser's reputation is based on his *Magdalene Altar* in Tiefenbronn. It is his only signed and authenticated work. It bears a strange inscription on its frame: "Schri kunst schri und klag dich ser, din begert iecz niemen mer so o we 1432 lucas moser, maler von wil maister dez werx bit got vir in." ("Cry, art, cry and lament greatly, for none covets thee now, oh woe! 1432 Lucas Moser, painter of Weil, master of this work, pray to God for him". The words may sound like the lament of an ageing artist, yet in terms of style Moser was one of the most modern. Perhaps no one wanted his art because it was too modern; perhaps his outburst can be traced back to the undercurrent of hostility towards painting following Huss's condemnation of icons and following the reforms of the Council of Constance. Moser was certainly familiar with northern Italian art, and perhaps also with earlier Tuscan painting. He probably visited Provence and southern France, and also had first-hand knowledge of Franco-Flemish innovations.

Of all the artists of his generation, Moser was probably the most modern and the closest to the new realism issuing from the Netherlands. The main front of the *Magdalene Altar* is divided into three scenes, all obeying the same perspective and lit from a single source. The pediment depicts the Feast in the house of Simon, while below we see the voyage of Saints Mary Magdalene, Martha, Lazarus, Maximinus and Sidonius (left); Saints Sidonius, Maximinus, Lazarus and Martha asleep (centre); St Mary Magdalene appearing to the prince and his wife in a dream (above); and the Last Communion of St Mary Magdalene (right).

The landscape and architecture create an astonishing impression of depth and are observed with a keen eye: the sea is partly underlaid with a sheet of metal foil to make it look more watery. The painted retable covers a fresco, but one hardly notices that the middle section of the altarpiece conceals a sculpture of the voyage of Mary Magdalene. The painter is not interested in making a distinction between a weekday and a feastday side of the altar – he simply wants to create a homogeneous, permanently visible panel of the kind with which he was familiar from Italy.

"cry, art, cry and lament greatly, for none covets thee now, oh woe! 1432 lucas moser, painter of weil, master of this work, pray to god for him."

Authentic inscription by the artist, written on the frames separating the single panels

Descent from the cross (central section of a triptych)

Tempera on wood, 220 x 262 cm
Madrid, Museo del Prado

* c. 1400 Tournai
† 1464 Brussels

Rogier was the leading Dutch painter to follow in the tradition of the brothers Jan and Hubert van Eyck. Unlike any other painter of the 15th century outside Italy, he extended Dutch art in respect of both composition and figure development, and his innovations became widespread in northern art. His influence spread as far as Italy, particularly with respect to his painting techniques, and he was much respected there. Surprisingly late, in 1427, he became a pupil of Campin. To identify his early work as that of his master, as has been attempted, is not tenable. In 1432 he became an independent master, and in 1436 official painter to Brussels city. A visit to Rome in the Holy Year of 1449/50 brought about the most fruitful exchange between Northern and Italian art in the 15th century. Rogier continued what Campin and also Jan van Eyck had begun, perfecting anatomical considerations and the perspectival representation of interior space and landscapes. Direct references to the older masters, such as in his various representations of St Luke painting the Madonna, which hark back to van Eyck's *Rolin Madonna*, became far less frequent from about 1440 as he strove to find an artistic balance between space and picture plane. The figures are more sparsely proportioned, interiors and drapery become more elegant, and the realistic depiction of detail gains in importance in the overall design.

Rogier was clearly thinking of an altar shrine with carved figures when he painted this panel, something evidenced not simply by the background with the flat moulding and ornamental tracery in its upper corners, but also by the composition of the figures as if in high relief.

Rogier's artistic temperament, so fundamentally different from that of Jan van Eyck, is here illustrated in exemplary fashion. In contrast to van Eyck's intuitive style of composition, Rogier adopts an intellectual approach in which everything is thought through to a remarkable degree. The pictorial plane is structured by means of corresponding or complementary lines of movement and direction, as illustrated in the figures of John on the far left and Mary Magdalene on the far right – mutually corresponding for all the differences in their expression and modelling – and in the repetition of the dead Christ's pose in the fainting figure of the Virgin Mary. Christ's and Mary's arms directly trace the two directions governing the composition.

In comparison to the powerfully modelled but, beneath their draperies, relatively undifferentiated figures of van Eyck, Rogier renders his figures in greater detail and allows their anatomical structure to emerge more clearly despite their elongated proportions.

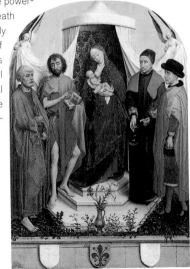

Medici Madonna, c. 1450–1460

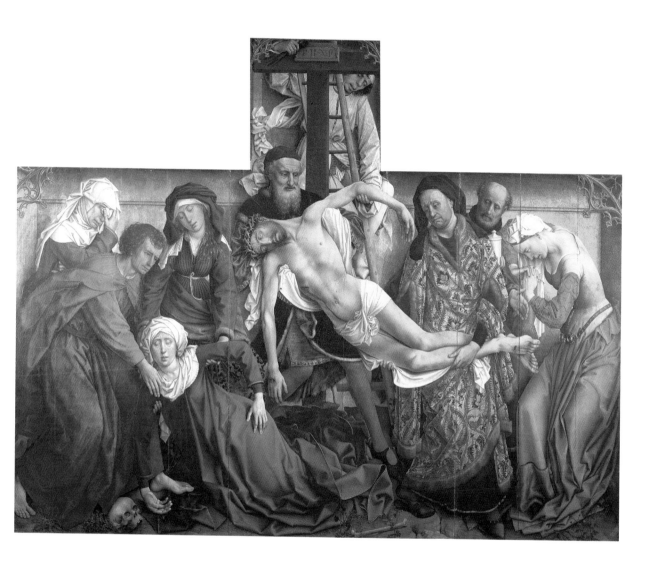

annunciation

Mixed technique on wood, 155 x 176 cm
Aix-en-Provence, Ste Marie-Madeleine (formerly in Saint-Sauveur cathedral)

Our knowledge of the life and work of this artist is based on a series of assumptions. It is thought that he trained in the workshop of Jan van Eyck, and from the 1440s onwards executed miniatures and panel paintings for René of Anjou and others of his circle. It is uncertain whether he accompanied René to Italy in 1440, during the latter's brief rule over Naples, or whether he was employed by the Dukes of Burgundy during that period. Following René's return in the mid-1440s, Barthélemy added about five miniatures to one of his older codices (London, British Library), and also illuminated a book of hours for him, in collaboration with Enguerrand Quarton (New York, Pierpont Morgan Library).

Between 1443 and 1445 he is believed to have executed a winged altarpiece for Aix-en-Provence. After another extensive series of miniatures, he produced his masterpieces, namely seven miniatures in a French edition of Boccaccio's *Théséide* (Vienna, Österreichische Nationalbibliothek) and the 16 illustrations to the *Livre du Cuer d'Amour espris* – these latter representing one of the supreme artistic achievements of their day.

Although Barthélemy d'Eyck can be assumed to be related to Jan and Hubert van Eyck, the present work falls fully in line with artistic practice in the Mediterranean sphere – from its thicker, less translucent application of paint to the gold brocade of the Virgin's cloak. At the same time, its astonishing realism at times goes far beyond even Netherlandish painting. There is a pronounced three-dimensionality to the composition as a whole; forms are weighty and substantial, while skin surfaces are sharply differentiated. Mary's hair is not perfectly coiffured, but instead full, almost flaxen. The wonderfully observed, plump cushions and the bunch of flowers also have a quite different spatial presence to their northern counterparts. This impression is reinforced on the one hand by the relatively plain metal jug and the quietly unforced arrangement of the flowering Marian symbols plucked, so it seems, at random from the garden, and on the other by the surrounding empty space and the sharp, spotlight type of lighting.

The architecture also appears solid and three-dimensional, and is wonderfully observed against the light – as in the tracery on the left above the angel's wing, and the roundel through which the Christ Child floats down, already shouldering his Cross. The figures listening to Mass and strolling around at the back of the church lend the composition an astonishing depth, even though the artist – doubtless deliberately – has not attempted to depict the room and the figures to scale. If the angel is assigned to the portico, but Mary to the whole church interior, this is certainly an allusion to the traditional identification of the Mother of God with the whole fellowship of Christians: in Mary, God is united in marriage with the Church. A particularly impressive piece of painting is represented by the wing, which is not stylized but depicted in all its nuances of colour and materiality, and by the wonderfully natural landscape behind it – evidently a natural study of Aix itself and its surroundings. The *Annunciation*, which since the Revolution has been kept in the church of St Mary Magdalene in the Provençal capital, was the main panel of an altarpiece which the clothmaker Pierre Corpici commissioned for the altar which he had endowed in the city's Saint-Sauveur cathedral. While the first impression is of a plain and monumental setting, the painter in fact pays loving attention to the details of the stained glass, the leaves flickering like flames on the capitals, and the heads and bats in the tracery.

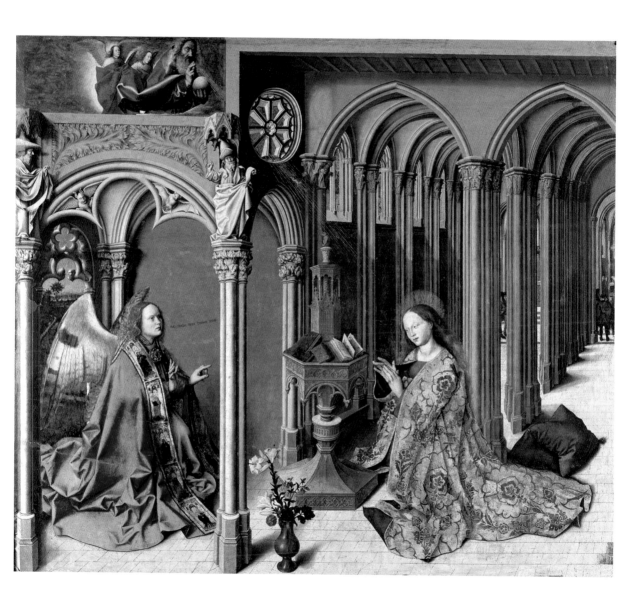

The miraculous draught of fishes

Tempera on wood, 132 x 154 cm
Geneva, Musée d'Art et d'Histoire

Witz was the most multi-talented German painter of the first half of the 15th century. His significance can be compared in various respects with that of Masaccio and Jan van Eyck. His birthplace, Rottweil, was an important centre of trade which was independent of any feudal or ecclesiastical authority, and must have helped fuel his interest in the portrayal of the real world. We nevertheless know little about his early training. Historical records yield only a few items of information about his life and work. In 1434 "Master Konrad of Rottweil" was admitted to the Basle Guild of Painters, and in the same year was granted citizenship of Basle. The last we hear of him is in the inscription accompanying *The Miraculous Draught of Fishes*, in which Witz gives his name and the date 1444. Witz addressed himself in equal measure to the problems of translating three-dimensional figures into two-dimensional painting, and of portraying interior and exterior spaces in correct perspective. In his sculptural treatment of the painted "statues" in his *Mirror of Salvation* altarpiece (Basle, Kunstmuseum, c. 1435), Witz surpassed his contemporaries in

Italy (Masaccio) and the Netherlands (van Eyck) to such a degree that it has prompted the question as to whether he was also a woodcarver. No proof of this exists. Although his interiors (e.g. *Annunciation* in Nuremberg, *Virgin and St Catherine in a Church*, Strasbourg) employ a mathematically imprecise system of perspective, they succeed in suggesting remarkable depth. Witz seeks to capture landscape and architecture with the greatest possible fidelity to life. While it can be confidently assumed that he was familiar with Netherlandish painting, it is possible, too, that he also had some knowledge of Italian art.

The Miraculous Draught of Fishes, the left wing of an altarpiece dedicated to St Peter, ranks amongst the milestones of Early Renaissance painting. For the first time in Western art we are shown a clearly identifiable landscape, namely the shores of Lake Geneva. The distinctive silhouette of the mountain behind Christ's head is that of the Dôle. The fundamental similarities and differences between painting north and south of the Alps can be seen here with particular clarity. While both are devoted with equal fervour to rendering the human body, spatial depth and landscape "correctly", the northerner devotes himself to the individual detail, the southerner to the principle behind the whole. The powerful robed statue of Christ, and the delicate glaze technique creating the masterly reflections on the surface of the water, point to the influence of Jan van Eyck. The contrast between the animated poses of the disciples and the monumental figure of Christ serves to isolate the latter from his immediate context and thereby emphasizes the miraculous nature of the events taking place.

The heads, damaged in a wave of iconoclasm in 1529, are the result of two restorations. The frame bears the inscription: "Hoc opus pinxit magister conradus sapientis de basilea 1444" ("This work was painted by Master Konrad Witz of Basle 1444").

Sabobai and Benaiah, c. 1435 (wing from the Mirror of Salvation altarpiece from St Leonhard, Basle)

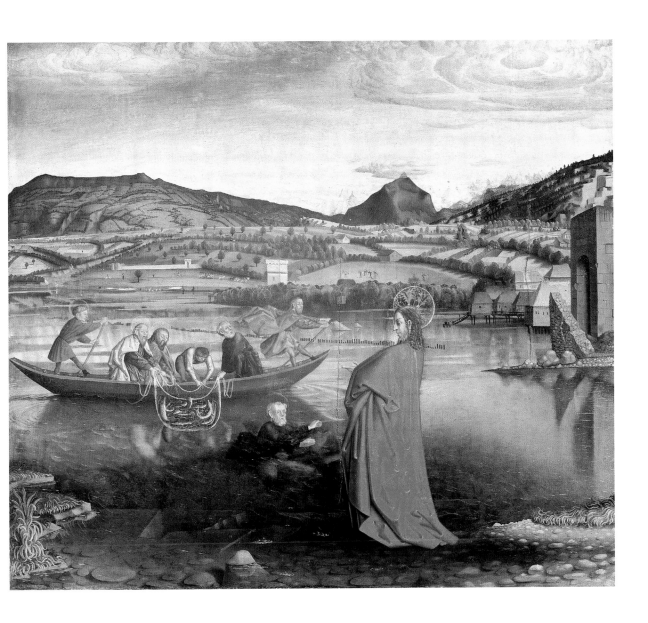

The virgin of the Rose Garden

Mixed technique on wood, 51 x 40 cm
Cologne, Wallraf-Richartz-Museum

According to one source, Lochner (doc. 1442–1451) was born in Meersburg on Lake Constance, but subsequently left Constance for Cologne. It is not known where he was trained or when he came to Cologne. Most of his works would appear to date from the 1440s. Although Lochner must have been familiar with contemporary Netherlandish painting (Campin, van Eyck), its motifs are only rarely adopted directly. In Cologne, he undeniably oriented himself towards older painting. His art gives the impression of being first and foremost his personal own: any connections with earlier generations or other schools take second place. Lochner tailored his artistic means with great sensitivity to the subject, the genre, and the client.

In the confidence and sophistication of his compositions, he had no equal in central Germany until Schongauer. Lochner was elected to the city council of Cologne in 1447 and 1450. He also had a flourishing workshop, which continued after he died (of the plague) in 1451. His manuscript illuminations are probably essentially products of his workshop.

When assessing Lochner's historical significance, it is important to bear in mind that all his works arose after the death of van Eyck and Masaccio. But this is not to conclude that Lochner was an old-fashioned or even provincial painter. When it came to technique, he ranked alongside the best Netherlandish masters. He worked largely in oils, applying his paints in wafer-thin layers. Thus the luminosity of Mary's mantle is achieved not by mixing the blue with white, but by allowing the white ground to shine through. Just as he painted no shadows, but rather shading, so he also disliked radiant lustre and glittering light. He loved the matt shimmer of pearl and similar mild shades, avoided earth colours, and glazed his gold in order to subdue and modulate its gleam. In terms of technique, he was one of the greatest masters of the century.

His attitude towards the art of his Netherlandish contemporaries, who were primarily concerned with the faithful reproduction of reality, is stated in the large altarpiece which he executed for Cologne cathedral (ill. p. 21). The outer wings portray objects and space in a naturalistic style and take up the broken drapery motifs of the new painting of Robert Campin. The interior, however, reiterates the soft, solemn forms of the International Gothic. We sense that, for Lochner, these older compositional means and motifs represent not simply a stylistic ideal but an ideal way of life. He is drawn only to the gentle and sweet aspects of religion – we find no representations of the Passion in his art. Yet Lochner is never monotonous, but responds with appropriate solutions to each new commission and subject. Thus the *Adoration of the Child*, a simple, small-format domestic altar modestly executed without a gold ground, restricts itself to the Virgin and the Child, who is laid on a communion cloth like the Host. The background lacks virtually all spatial depth, its details merely grouped around the figure of Mary dominating the pictorial plane. By contrast, the *Presentation in the Temple*, painted for a high altar, is much richer, more complex and more ostentatiously splendid.

Lochner displayed his greatest delicacy and sensitivity in his painting of *The Virgin of the Rose Garden*. In contrast to other versions of the subject, there is nothing here to distract attention from the person of Mary. The panel is primarily a statement of the Virgin's humility and apotheosis, and only secondly a portrayal of her characteristics (the flowers as symbols of her virtues, the unicorn brooch as a token of her virginity, the crown as a sign of her royal rank). Lochner employs the entire spectrum of his artistic means to express the purity, lightness and sweetness of his subject.

madonna and child, (left half of the melun Diptych)

Tempera on wood, 91 x 81 cm
Antwerp, Koninklijk Museum voor Schone Kunsten

* c. 1414/20 Tours (?)
† 1480 Tours

Historical records provide almost no information about the life and work of the most famous French painter of his day. His only authenticated works are the miniatures in the *Antiquités judaïques* (Paris, Bibliothèque Nationale). That he was a painter of international repute is evidenced by documentary sources from the 15th and 16th centuries, which allow us to reconstruct his career. Fouquet probably learnt the art of manuscript illumination under Flemish-Burgundian masters, possibly the Limburg brothers. The illumination of lavish manuscripts clearly remained a central focus of his art throughout his life. In the 1440s Fouquet went to Italy, where he painted a portrait (now lost) of Pope Eugene IV, who died in 1447, giving us an approximate date for Fouquet's visit. He must also have attained a certain degree of fame to have attracted a commission from such high quarters; since a reputation takes time to build, this same commission allows us to at least approximate Fouquet's date of birth. Fouquet's confrontation with Italian painting – and in particular with the more three-dimensional modelling of the human figure in the work of Uccello and Castagno – exerted a pronounced influence upon his own style. As court painter to the French king from 1475, he succeeded in fusing these diverse influences into a courtly classicism unique in the painting of the 15th century, characterized by compositional rigour and a certain detachment.

This panel forms the left-hand side of the *Melun Diptych* commissioned for the tomb of Etienne Chevalier, treasurer to King Charles VIII of France. The right-hand panel (Berlin) shows the figure of the donor being commended to the Virgin by a saint.

Although the outwardly sacred character of the subject is emphasized by the presence of the angels, the panel nevertheless seems to cross the border into the sphere of the profane. This impression is reinforced by the portrait-like features of the Madonna – the model for whom is traditionally said to have been Agnes Sorel, the King's mistress – and by the exposure and modelling of her breast, a motif not demanded by the subject but possessing an erotic value in its own right.

Here we see a prime example of a work of art hallmarked by the conventions of its social background. Fouquet, court painter to the king, accorded aristocratic sophistication – indeed, affectation – a significance unique in the painting of the mid-15th century. Even the unreal contrast of red and blue in the angels fails to erase the panel's sense of worldliness. The painter shows no interest in the logical composition of spatial depth. Colours are strongly contrasted. In his execution of the ornamental details of the crown and throne, however, Fouquet displays a high degree of sensitivity, evidence that he was familiar with early 15th-century Netherlandish art.

Second Annunciation,
c. 1453–1456

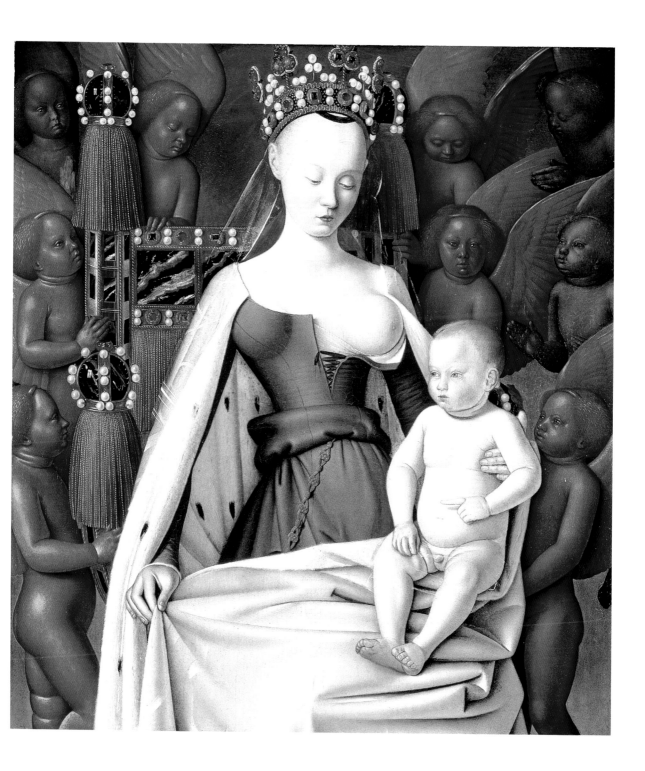

saints Abdon and sennen

Mixed technique on wood, c. 290 x 220 cm
Terrassa, Santa Maria d'Egara

Huguet is an exemplary representative of Catalan painting of the 15th century, which remained indebted to medieval tradition and almost untouched by the innovations of the Early Renaissance. There are no records documenting his work before the year 1448, when he was commissioned to paint a St James altar for Arbeca. Between then and 1486, he executed a lengthy series of polyptychs, of which his *Saints Abdon and Sennen Altar* (1458–1460) and *Three Kings* altar (Barcelona, Museo de Historia de la Ciudad, 1464) stand out in particular. Huguet's painting underwent no notable stylistic development. He generally stuck to a gold background; spatial details were kept to a minimum, and the two-dimensional plane prevailed over physical volume. Huguet was so busy that he gradually employed more and more assistants in his workshop, which resulted in his works deteriorating in technical quality and becoming somewhat hackneyed in their appearance.

Jaume Huguet's best-preserved work is his *Saints Abdon and Sennen Altar*, executed for St Peter's church in Terrassa, near Barcelona. Our detail shows the main picture, featuring the standing figures of the two martyrs of late antiquity. Although today relatively unknown, in Huguet's day they were highly revered by Catalan farmers. Their story was also included in the most famous medieval collection of biographies of saints, the *Golden Legend*. Abdon and Sennen were two lesser kings from the south of Spain, who took the bodies of Christians martyred at the hands of the emperor Decius and buried them in Cordoba. Decius subsequently had them bound in chains and taken to Rome. When they refused to sacrifice to the heathen gods, and even spat upon their idols, they were thrown to the wild beasts in the circus. Since the two lions and four bears stood guard around them rather than tearing them to pieces, they were eventually put to death by the sword. Huguet portrays the two martyrs dressed in the style of nobles of his day. The crowns which they wear on top of their fashionable hats indicate their royal rank. In their hands they carry the instruments of their martyrdom. Tall, slender, almost boringly well-proportioned figures, with gentle faces and even features, were one of the painter's hallmarks. At the same time, they are probably not uninfluenced by the work of the Netherlandish artist Dieric Bouts (ill. p. 83). Huguet shades their faces with a gentle hand and carefully details the various materials making up their rich costumes.

In a similar fashion to Cologne, Catalonia continued to employ lavish gold grounds far longer than in the Netherlands. In the present example, Huguet has even tooled a tendril pattern into parts of the gilding, while introducing raised relief into the crowns, haloes and decorative details. In a juxtaposition typical of the Late Gothic style, the panel's true date is betrayed by the modern foreshortening of its tiled floor and its landscape background. Despite Huguet's rather unconvincing cliffs, his expansive plain and his trees of staggered heights combine to achieve a relatively natural effect, based on Italian models.

The layout of the retable has barely altered since the days of Perre Serra and Bernat Martorell. The central picture is crowned by a *Crucifixion*, and flanked on both sides by two episodes from the lives of the saints to whom the altarpiece is dedicated. Alongside their trial and martyrdom, these include the legendary transport of Abdon and Sennen's bones in two wine vats strapped to a donkey. In this way they are supposed to have been carried to Arles del Tec (Arles-sur-Tech) in northern Catalonia, today part of France. Although important classical ruins were still standing in Catalonia, Huguet portrays the Roman circus as a walled quadrangle.

JAIME HUGUET · 1450-1492

Last supper from the Last supper Altar

Tempera on wood, 180 x 150 cm
Louvain, St Peter

* c. 1410/20 Haarlem
† 1475 Louvain

Alongside Memling, Bouts can be considered the most important successor to Rogier van der Weyden. Little is known about his training and early work. Even if not actually a pupil of Rogier himself, Bouts was profoundly influenced by his work. He developed Rogier's style to an almost radical degree in his verticalization of architecture and figures, his reduction of the individual in favour of the type, and his concealment of the body behind exquisite, minutely detailed garments. Whether we can view these as the first indications of a specifically northern Netherlandish art with a Protestant flavour, or whether Bouts was simply part of the more general trend sweeping over Europe after the middle of the century, is hard to decide. Whatever the case, the stylistic features already described intensified from the Eucharist Altar in Louvain (1464–1467) to the *Justice* panels in Brussels (begun 1468). In 1465 Bouts married Katharina van der Brugghen, the daughter of a respectable Louvain family. He remained based in Louvain, enjoying an excellent reputation as a painter. He is last mentioned in records dated 17 April 1475. It is still frequently difficult to draw a clear line between his own work and that of others, including his son Dieric Bouts the Younger. It is therefore impossible to determine the full scope of his art. If the winged altar at Munich known as the "Pearl of Brabant" is indeed by his hand, then he must have been one of the greatest landscape painters of his generation.

This *Last Supper* from Sankt Peter in Louvain forms the central panel of a winged altarpiece commissioned by the confraternity of the Holy Sacrament. The painter was bound by contract to execute the work himself and thereby to follow the directions of two professors of theology.

For the first time, we are shown not the moment when Christ announces his impending betrayal, but the institution of the Communion. By its very nature, therefore, it is not a scene of intense drama – something which clearly suited the artist's temperament. In comparison to the masters of the early 15th century, Bouts undoubtedly creates a spacious setting, but one which feels more "empty" than solid. The impression of depth is countered by the verticals typical of the period after 1450, as seen in the portrait format, the almost bird's-eye view of the floor, and the many perpendicular elements in the side walls.

The severity of the composition makes the whole seem less lifelike and distances us from the scene. The skilfully emphasized central axis is also the axis of symmetry. The corporeality of the figures is sharply reduced, and the disciples seen from the rear in front of the table almost resemble flat planes of drapery folds. Overall, the panel contrasts sharply with the sensual wealth so characteristic of the 15th century.

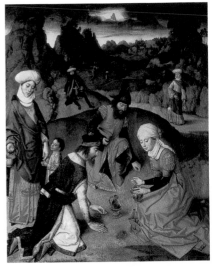

Gathering Manna, 1464–1468

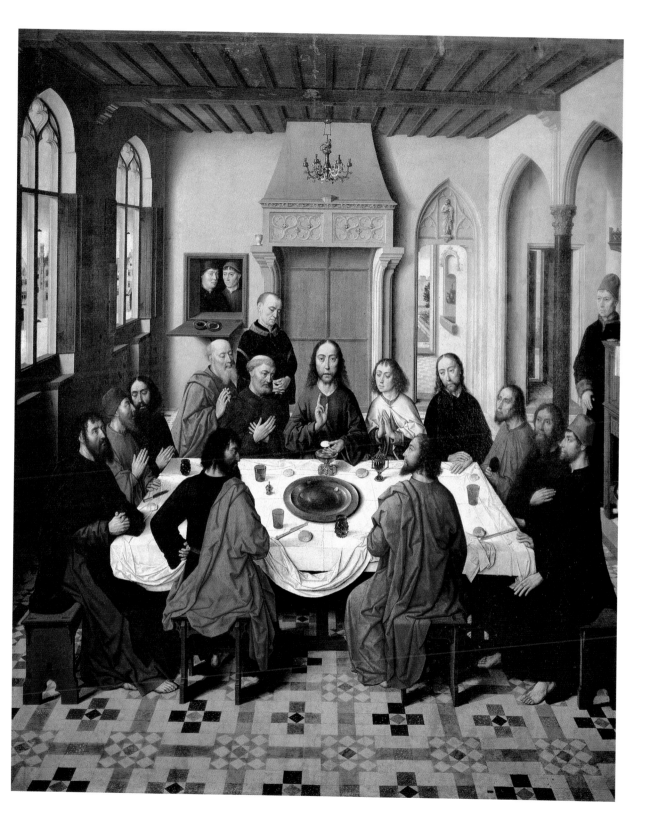

portrait of a Lady

Oil on wood, 28 x 21 cm
Berlin, Gemäldegalerie, Staatliche Museen zu Berlin – Preussischer Kulturbesitz

After a long period in oblivion, Christus is today regarded as Jan van Eyck's successor. He was probably van Eyck's pupil, and on his death took over the workshop and completed van Eyck's unfinished work. His significance today lies in his further development of the art of perspective. He was the first painter in the North who arrived empirically at the law of linear perspective and who applied it. His significant portraits are marked by their concentration on just a few characteristic details. He was also the first Dutch master to place the sitter not before a neutral background but in front of a recognisable interior. After he was made master and burgher of Bruges in 1444, van Eyck's influence waned and was replaced by his interest in van der Weyden and Campin. His representation of background, often in the form of landscapes in a mood of quiet harmony, influenced later Netherlandish painters, in particular Bouts, Ouwater and Geertgen. There was no further development in his later work, of which only six signed and dated pictures survive.

This portrait of a young woman denotes a new stage of development in Netherlandish portraiture. The sitter is no longer set against the foil of a neutral, impersonal ground, but is now placed in an actual physical context: it appears to be a room. Direct contact is established between the spectator and the subject in her own environment.

The work bears witness to a stylistic change which took place after the middle of the 15th century. The emphasis upon volume encountered in the portraits of Roger Campin and Jan van Eyck is here sharply reduced. The elongation evident in the proportions of the narrow upper body and head is heightened by the V-shaped neckline of the ermine collar and the cylindrical hat.

The middle-class realism embraced by the generation of artists at the start of the 15th century is here replaced by an element of aristocratic sophistication. The strip of moulding separating the wood panelling on the lower back wall from the plaster above divides the painting exactly in half; with its emphatic horizontal, it provides a harmonious counterbalance to the vertical format and as such forms an essential component of the composition. In the delicate execution and almost tangible textures of the costume, trimmings and jewellery, Christus reveals himself a pupil of Jan van Eyck.

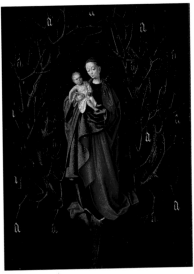

Madonna in a Dead Tree, c. 1460

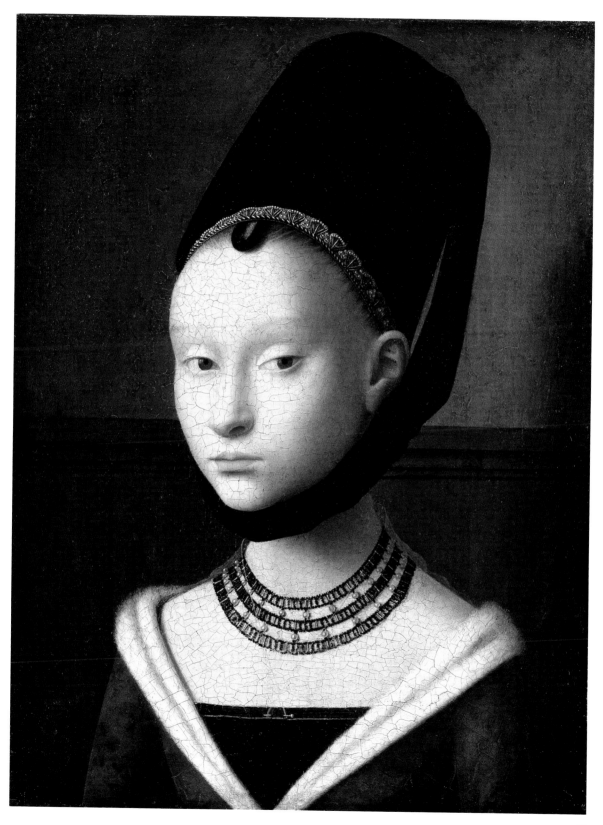

The Resurrection of Lazarus from the st wolfgang Altar

Tempera on wood, 175 x 130 cm
St Wolfgang, high altar of St Wolfgang's church

Pacher was one of the few 15th-century artists equally gifted in painting and wood sculpture. His training and early work are still a matter of conjecture. His altarpiece in the Liebfrauenkirche of Sterzing, completed in 1457/58, may have been inspired by Multscher. Records show that Pacher was active in Bruneck in 1467, where he ran a large workshop. His altarpiece depicting the crowning of Mary in the shrine of the parish church in Gries near Bozen, begun in 1471, was a preliminary step to his masterpiece in St Wolfgang in the Salzkammergut, a winged altar combining reliefs, statues and panel paintings. For this, the contract was signed in 1471, and Pacher himself had to deliver the work, signed 1481, to St Wolfgang and to install it. In this work, the crowning of Mary interweaves with the rich forms of the tracery into a unified pattern of lines, and light and shade create the suggestion of unlimited depth. The life-size figures, in particular those of St Wolfgang and St George beside the closed shrine, reveal Pacher as a contemporary of Verrocchio and Pollaiuolo: both north and south of the Alps, efforts were being made to depict the human figure moving in space and seen from different angles. The paintings of the altar wings are reminiscent of the works of Mantegna in their bold treatment of perspective, which Pacher could possibly

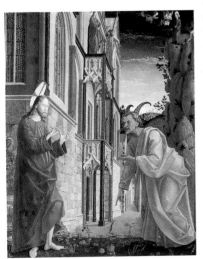

The Temptation of Christ, 1471–1481

have studied in Verona, Mantua and Padua. And while Pacher the wood-carver introduces elements of this art into painting, the painter in Pacher uses his insight into carving to deal with surface. With the *Church Fathers Altar* created in 1483 for the Neustift monastery near Brixen, Pacher reached a point at which the borders between painting and sculpture in the North were no longer clearly distinct.

The Resurrection of Lazarus deviates from iconographical tradition in a number of respects. Firstly, the scene is moved into an indoor setting whose architecture reveals an astonishing mixture of contemporary forms borrowed from both the sacred and the secular spheres. Secondly, the narrative unfolds not from left to right, but from foreground to background. It is true that Lazarus' sisters are kneeling parallel to the pictorial plane in the foreground, and that Christ is gesturing in the same direction, but Lazarus himself is seen from behind and foreshortened towards the rear. The main lines of the composition reinforce this inward movement – the vaulted canopy above the tomb, for example, the arrangement of the figures into lines resembling a guard of honour, and finally the view through the arch in the central axis out into the distant landscape. The New Testament subject is effectively obliged to take second place in this demonstration of the painter's supreme mastery of perspective.

Pacher must undoubtedly have studied the works of Andrea Mantegna, and the figure of Lazarus almost seems to anticipate the latter's *Dead Christ*. The principle underlying Pacher's composition points even further into the future, however, insofar as the vanishing lines converge not upon one central object or figure, but rather allow the eye to escape, as it were, out into the open countryside.

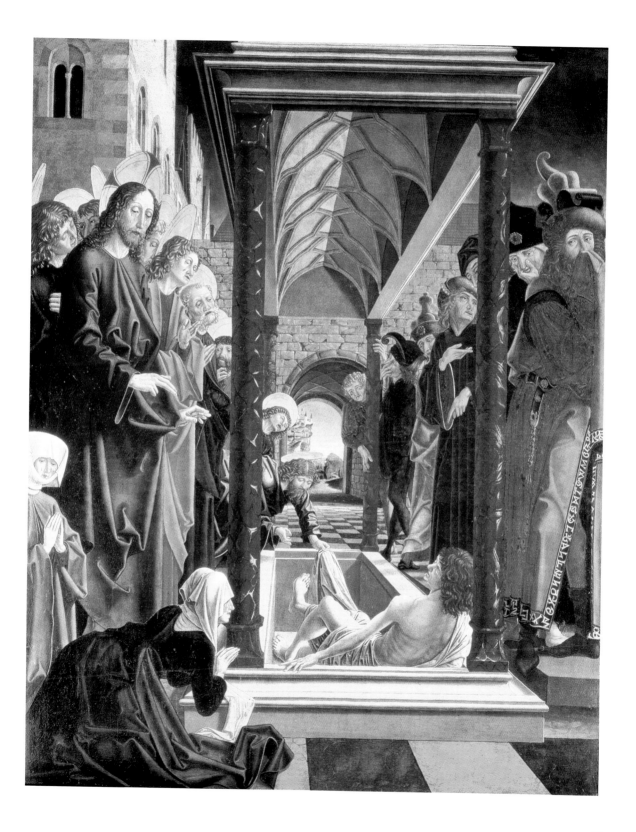

HANS MEMLING

The Mystic Marriage of St Catherine from the St John Altar

Oil on oak, 173.6 x 173.7 cm
Bruges, Stedelijke Musea, Memlingmuseum

c. 1430/40 Seligenstadt (Main)
† 1494 Bruges

Little is known about his apprenticeship and early work. He may have trained in a Middle-Rhenish or Cologne workshop before moving to the Netherlands. In 1465 he is documented in Brussels; from 1466 he was active in Bruges. He was probably amongst the last pupils of van der Weyden. Whatever the case, Memling's earliest authenticated works are greatly influenced by him, right down to their composition. The young artist was also impressed by the work of Bouts, as evidenced by his *St Mary Altar* of 1468 (London, National Gallery). He subsequently evolved his own style, which is characterized by the graceful movements and expressions of his figures, an exquisite palette and a wealth of narrative detail. Up to a certain point, Memling could be described as the Gozzoli of Netherlandish painting. He lacks depth of expression and the ability to handle crowd scenes convincingly. Memling's paintings are the sum of accurately observed and life-like details (*Scenes from the Life of Mary*, Munich, Alte Pinakothek, 1480). He reveals little personal development. The influence of the Italian Early Renaissance can be felt in his late work, albeit restricted to isolated elements (*Madonna and Child*, Florence, Uffizi).

The fact that Memling moved from the Main region to the Netherlands demonstrates the powerful magnetism exerted by the small but prosperous region, with its highly sophisticated culture. Memling, on the other hand, also contributed much to the popularity and attraction of Early Netherlandish art. Although Florentine art and Venetian art were themselves just reaching the peak of their perfection, Memling's works were highly prized in Italy nonetheless. His reputation becomes understandable in view of the unswervingly high standard of craftsmanship which distinguishes his œuvre, in all its scope. His temperament seems to be wholly directed towards calm, harmony and solidity. He ultimately lacks the powers of invention and observation of Hugo van der Goes, even though he adopts many of the Ghent artist's innovations and makes them his own. The central panel of Memling's *St John Altar*, one of his richest works, brings together many of the typical characteristics of his art. The angels have no more need for wings than the saints for nimbuses, so normal has it become to use realistic forms taken from everyday life for religious subjects. St Barbara and St Catherine are identified by their attributes of the tower and the wheel respectively. The fact that the faces are so alike is explained not just by the limitations of the artist: it is also part of his programme.

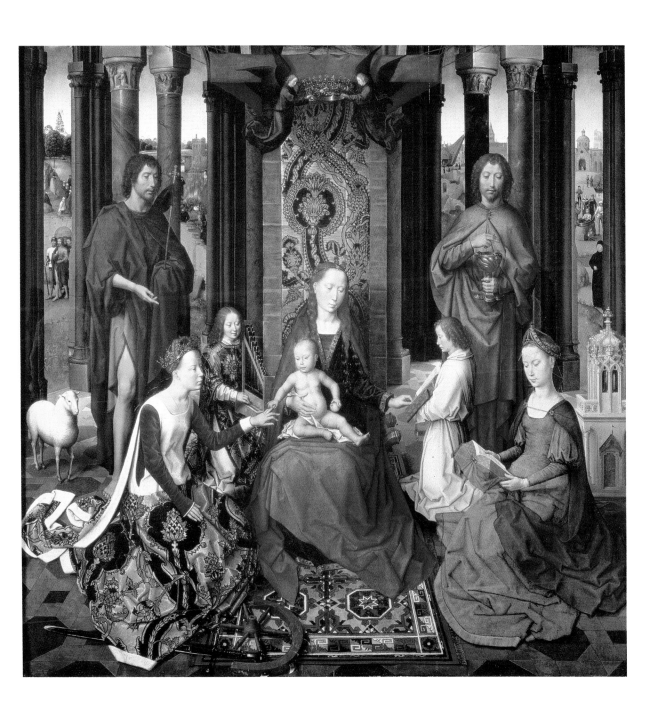

Moses and the Burning Bush

Mixed technique on wood, 305 x 225 cm
Aix-en-Provence, Saint-Sauveur cathedral

Together with the Master of the Aix Annunciation and Enguerrand Quarton, Froment illustrates the rich variety which characterized Provençal painting in the 15th century. Thanks to its geographical location, Provence was open to the most diverse influences. As Froment painted his first authenticated work – a *Lazarus* triptych (Florence, Uffizi) for the Minorite priory in Mugello near Florence – in 1461, his date of birth can be put at around 1430 at the latest. Although probably executed in Italy, the triptych shows no Italian influences whatsoever, but suggests that Froment trained in the Netherlands in the circle of Bouts. Records give Uzès as his place of birth. The fact that he owned several houses in Uzès around 1470 indicates a healthy income earned from important commissons. From 1475/76 he was connected with the court of King René, for whom he executed his surviving masterpiece, the *Moses* triptych in Aix-en-Provence. He subsequently decorated the royal residence in Avignon, and his name appears repeatedly in account books until 1479. Sadly, these works have no more survived than his designs for tapestries and festive decorations.

Buried beneath the triptych to which this panel originally belonged were the viscera of Good King René. The central panel is devoted to a scene from the Old Testament. To find such a subject at the centre of a large altarpiece is something one might otherwise expect virtually only in Venice, where entire churches were dedicated to Old Testament figures such as Job and Zachariah. The unusualness of this choice is thereby tempered by the fact that the divine apparition seen by Moses in the middle of the burning bush is here interpreted as the Mother of God. Hence, too, the play upon the Marian symbol of the rose, as clearly evident in the foliage and the numerous white blooms woven around the Virgin and Child.

There seem to be formal echoes, too, of the Revelation of St John on Patmos. Just as John saw Mary "clothed with the sun", she is here surrounded by the flames which, according to the Bible, miraculously engulfed the bush without burning it up. Beneath her, Moses is tending the flocks of his father-in-law Jethro. Equally important within the composition is the large figure of the angel, who commands Moses to take off his sandals because he is standing on holy ground. The Fall depicted on the large clasp holding together the angel's liturgical vestments again makes reference to Mary, who represented the new Eve through whom the curse of the Fall was expunged. Just as the name of Eva (Eve) is reversed into the "Ave" spoken by the angel, so the mirror in the hand of the Child – another extravagance in this altar – seems to reverse the picture of the Original Sin into the picture of Salvation. Moses, on the other hand, as one of the unbaptized living before the birth of Christ, has to raise his hand to protect his eyes from the brilliance of the celestial vision.

The introduction of the angel allows Froment a strict triangular composition. The rocky outcrop, an abbreviation for the biblical Mount Sinai, divides the landscape into three sections, which bear almost no relation to each other either in their motifs or in their perspective. The particularly naturalistic idyll between Moses and the angel deserves the closest attention, despite its exaggeratedly winding stream. The sheep in the middle ground are especially successful, although the outstanding individual studies in the foreground are somewhat abruptly juxtaposed. A "black sheep" in the centre, with a wonderful gleam in its eye, ensures that the white goats and sheep can at least here be told apart. The watchful sheepdog with the heavy spiked collar lying at Moses' side is drawn and painted in masterly fashion. The altar is unmistakably a product of the Mediterranean sphere. Whereas its borrowings from Netherlandish realism remain somewhat generalized, the background landscape on either side of the hill looks, upon closer inspection, directly back to earlier Italian, and specifically Florentine, painting. A rarity in its own right is the illusionistic frame, which imitates a precious piece of jewellery.

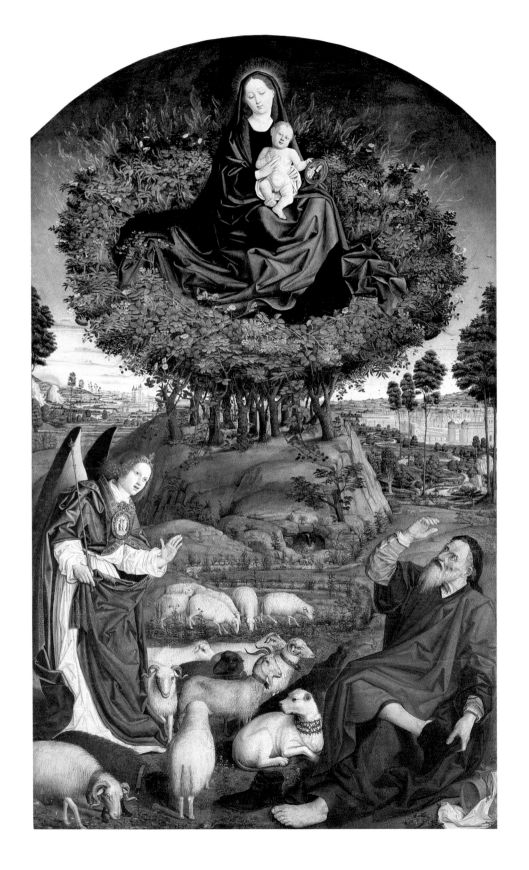

The Adoration of the shepherds from the Portinari Altar

Oil on wood, 253 x 304 cm
Florence, Galleria degli Uffizi

c. 1440 Ghent
† 1482 near Brussels

Van der Goes is, apart from the somewhat younger Bosch, the most important Dutch painter in the second half of the 15th century. Little is known about his life, and his artistic origins are also unclear. A certificate of 1480 confirms that his home town was Ghent, and as he was granted the master title in Ghent in 1467, he must have been born about 1440–1445. As early as 1477 he abandoned his workshop, entering the Red Monastery near Brussels where he died in 1482 after a severe mental illness. His masterpiece, known as the Portinari Altarpiece is the only surviving work that can be attributed to him with absolute certainty, although there are others that can be assigned to him with some safety (*Monforte Altarpiece*, diptych depicting the *Fall of Adam*, the *Lamentation of Christ and St Genoveva*, Vienna, Kunsthistorisches Museum). Hugo van der Goes had at his disposal all the techniques of the earlier Dutch masters, in particular Rogier van der Weyden, as regards spatial disposition, the true-to-life construction of the human body and the representation of luxurious detail to look like the real thing. Yet he handled these devices in a completely different sense, putting to service the heightened expressiveness of gestures and faces, and not excluding the "uncomely". With his *Portinari Altarpiece* he brought about a revolution in Florentine painting, as the works of Ghirlandaio and Filippino Lippi demonstrate, but which becomes most evident in Leonardo da Vinci's work.

The Adoration of the Shepherds, the most important work by the greatest Netherlandish painter of the late 15th century, has a unique historical and artistic significance. The altar was donated to the Florentine church of San Egidio by Tommaso Portinari, who since 1465 had been living in princely style in Bruges as manager of the Medici family's commercial interests. The central panel is flanked by two wings depicting other members of the Portinari family and the family's patron saints, with a grisaille Annunciation on their reverse.

From an artistic point of view, the differences between this work and those of the preceding generation, and indeed earlier paintings by the same master, are astounding. While space and anatomy are easily mastered, they are no longer major themes of the composition. The infant Jesus lies within an aureole in an outdoor square, surrounded by his parents, clusters of angels and the worshipping shepherds. The more or less circular arrangement of the figures can be perceived equally in three-dimensional and two-dimensional terms. While the figures may have lost volume in comparison to the *Monforte Altar*, their faces and gestures have gained in expressiveness. A certain impression of spatial depth is suggested by the figures' varying distances from the front of the picture and by the oblique line running from the Antique-style column beside Joseph in the left-hand foreground, through the manger with the ox and ass, and on through the buildings in the middle ground. Its logic is overthrown, however, as the artist reverts to the medieval system in which figures are portrayed on a scale directly related to their importance. Thus the angels in the foreground are surprisingly small in comparison to Mary and Joseph – a contrast repeated in the sizes of the donors and saints portrayed in the wings.

Details such as the angels in their copes and the still life of flowers in the foreground are executed with an exquisite delicacy unsurpassed in the entire painting of the Early Renaissance.

The influence of the *Portinari Altar*, which was erected in Florence in 1478, was felt by many of the Florentine painters and is reflected in particular in the works of Ghirlandaio and Leonardo.

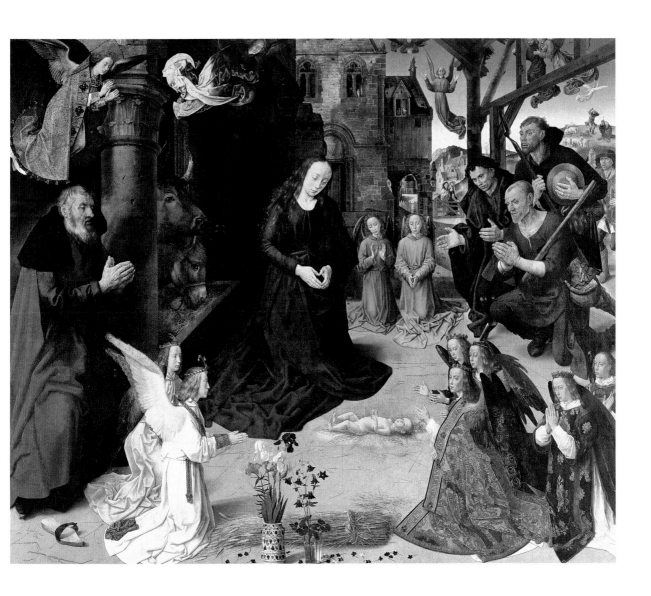

adoration of the shepherds

Mixed technique on oak, 37.5 x 28 cm

Berlin, Gemäldegalerie, Staatliche Museen zu Berlin – Preussischer Kulturbesitz

* c. 1450 Colmar
† 1491 Colmar

His name probably derives from the town of Schongau, although from 1329 the family are documented in Augsburg, where they were members of the gentry. Schongauer's father Caspar, evidently a well-known goldsmith, moved from Augsburg to Colmar in 1445. Having first been sent to Leipzig to study at the university, Martin subsequently returned to his father's workshop, where he learned the engraving and drawing which would prove so decisive for his future. Only then did he go on to train as a painter, probably under Caspar Isenmann in Colmar. Schongauer is the most important engraver and draughtsman in German art before Dürer. Schongauer's painting is characterized by his mastery of the fine detail, primarily rendered through fanciful line. In this he follows the general trend in European art in the 1470s and 1480s – comparable, for example, to Botticelli in Italy, only a few years his senior. Stylistic features of his figural and landscape painting suggest that Schongauer visited the Netherlands, where he must have been profoundly influenced by the works of van der Weyden and his followers.

The firm outlines, the rich detailing of every inch of the plane, and the precision of the drawing of the folds and hair betray the hand of the experienced graphic artist. Schongauer was also developing his mastery of colour and painterly effects, as evidenced not just by the reflections in the distant lake. He demonstrates his abilities in particularly impressive fashion in his accurate portrayal of the moth-eaten fringed blanket with the black and gold stripes, seen beneath the swaddling clothes on which the Infant Jesus is lying. That Schongauer was using the realistic portrayal of fabrics to showcase his talents is confirmed by the tattered clothes worn by the shepherds and the equally well-worn bags tied to Joseph's staff, which lead the viewer into the picture. Another indication of how carefully the artist has planned his composition is the diagonal descending through the heads of Joseph and Mary to the Child. Together with the calm poses of the three main figures, the faces of the shepherds and the head, seen frontally behind Christ, of the ox, it relegates the genre-like elements to the background. Thus silent adoration is truly able to become the subject of the painting, more than in the other Adorations of the day. In 1859 the panel was in Palermo and thus bears witness to the enduring enthusiasm – evidenced as early as 1505 – with which Schongauer's works were collected.

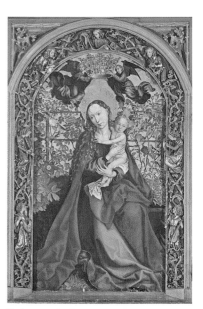

Madonna of the Rose Bower, 1473

To stay informed about upcoming TASCHEN titles, please request our magazine at www.taschen.com/magazine or write to TASCHEN America, 6671 Sunset Boulevard, Suite 1508, USA-Los Angeles, CA 90028, contact-us@taschen.com, Fax: +1-323-463.4442. We will be happy to send you a free copy of our magazine which is filled with information about all of our books.

© 2006 TASCHEN GmbH
Hohenzollernring 53, D–50672 Köln
www.taschen.com

Project management: Juliane Steinbrecher, Cologne
Editing: Stilistico, Cologne
Translation: Karen Williams, Rennes-le-Château
Design: Sense/Net, Andy Disl and Birgit Reber, Cologne, and Tanja da Silva, Cologne
Production: Martina Ciborowius, Cologne

Printed in Germany
ISBN 10: 3-8228-5292-9
ISBN 13: 978-3-8228-5292-7

Photo Credits:
The publishers wish to thank the museums, private collections, archives and photographers who granted permission to reproduce works and gave support in the making of the book. In addition to the collections and museums named in the picture captions, we wish to credit the following:

© Archiv für Kunst und Geschichte, Berlin: pp. 19, 69
© Artothek, Weilheim: pp. 11 right, 12 left, 53, 56, 57, 59, 71, 74, 83, 89, 93
© Artothek – Alinari: p. 33
© Bildarchiv Preussischer Kulturbesitz, Berlin 2006 – Jörg P. Anders: p. 43, 51, 63, 85, 95
© Bridgeman Art Library, London: pp. 4, 15, 18 right, 29, 40, 41, 45, 47, 65, 67, 73, 75, 79, 87, 91
© 1990, Foto Opera Metropolitana Siena/Scala, Florence: p. 35
© 1990, Foto Scala, Florence: pp. 37, 39, 48, 49
© The National Gallery, London: pp. 54, 55
© Photo RMN, Paris – Jean-Gilles Berizzi: p. 46
© Rheinisches Bildarchiv, Cologne: pp. 21, 77

Reference pictures:
p. 26: Workshop of the Ingeborg Psalter, *Events from the Life of Christ*, c. 1195. Manuscript illumination, 304 x 204 cm. Chantilly, Musée Condé
p. 30: Workshop of Cimabue, *Madonna and Child with Angels and Saints Francis and Domenico*, c. 1290–1310. Tempera on wood, 133 x 82 cm. Florence, Galleria degli Uffizi
p. 40: Workshop of the Papal Palace, *Falconry*, 1343. Al secco painting and fresco. Avignon, Papal Palace, north wall of the Deer Room in the Tour de la Garde-Robe
p. 44: Master Theoderic, *St Gregory*, c. 1360–1365. Tempera on wood, 113 x 105 cm. Prague, Narodni Galeri
p. 46: Girard d'Orléans, *Portrait of John II "The Good", King of France*, c. 1349. Tempera on canvas on wood, 59.8 x 44.6 cm. Paris, Musée du Louvre
p. 48: Andrea da Firenze, *Triumph of Saint Thomas Aquinas*, c. 1367. Fresco (detail). Florence, Santa Maria Novella, Chiostro Verde, Cappellone degli Spagnoli
p. 54: Master of the Wilton Diptych, *King Richard II of England (kneeling) with his patron saints*, c. 1395. Tempera on wood, 45.7 x 29.2 cm. London, National Gallery
p. 56: Master of the Upper Rhine, *Madonna of the Strawberries*, c. 1420. Oil on wood. Solothurn, Kunstmuseum
p. 58: Master of St Veronica, *Calvary Hill*, c. 1415. Oil on wood, 50.7 x 37.5 cm. Cologne, Wallraf-Richartz-Museum
p. 60: Lorenzo Lotto, *Annunciation*, c. 1410–1415. Tempera on wood, 130 x 230 cm. Florence, Galleria dell'Accademia
p. 62: Master Francke, *The Miracle of the Wall*, 1414. Mixed technique on wood, 91.5 x 54 cm. Helsinki, Kansallimuseum
p. 64: Robert Campin, *Annunciation*, not dated. Tempera on wood, 61 x 63 cm. Brussels, Musées Royaux des Beaux-Arts
p. 70: Rogier van der Weyden, *Medici Madonna*, c. 1450–1460. Oil on wood, 61.7 x 46.1 cm. Frankfurt am Main, Städelsches Kunstinstitut und Städtische Galerie
p. 74: Konrad Witz, *Sabobai and Benaiah*, c. 1435. Tempera on wood, 102 x 78 cm. Basle, Kunstmuseum, Öffentliche Kunstsammlung
p. 78: Jean Fouquet, *Second Annunciation*, c. 1453–1456. Manuscript illumination, c. 20.1 x 14.8 cm. Chantilly, Musée Condé
p. 82: Dieric Bouts, *Gathering Manna*, 1464–1468. Oil on wood, 87.6 x 70.6 cm. Louvain, Sankt Peter
p. 84: Petrus Christus, *Madonna in a Dead Tree*, c. 1460. Oil on wood, 17.4 x 12.3 cm. Madrid, Museo Thyssen-Bornemisza
p. 86: Michael Pacher, The Temptation of Christ, 1471–1481. Mixed technique on wood, c. 175 x 130 cm. St Wolfgang, church
p. 94: Martin Schongauer, *Madonna of the Rose Bower*, 1473. Tempera on wood, 200 x 115 cm. Colmar, Dominican church

Page 1
MASTER OF THE ST VITUS MADONNA

Madonna
c. 1390–1400, Tempera on wood, 89 x 77 cm
Prague, Národni Galeri

Page 2
GIOTTO DI BONDONE

The Devils Cast out of Arezzo
c. 1296/97, Fresco (detail)
Assisi, San Francesco

Page 4
HUGO VAN DER GOES

Death of the Virgin
c. 1480, Oil on wood, 147,8 x 122,5 cm
Bruges, Groeningemuseum

gothic

ROBERT SUCKALE, MATTHIAS WENIGER & MANFRED WUNDRAM
INGO F. WALTHER (ED.)

TASCHEN

HONGKONG KÖLN LONDON LOS ANGELES MADRID PARIS TOKYO

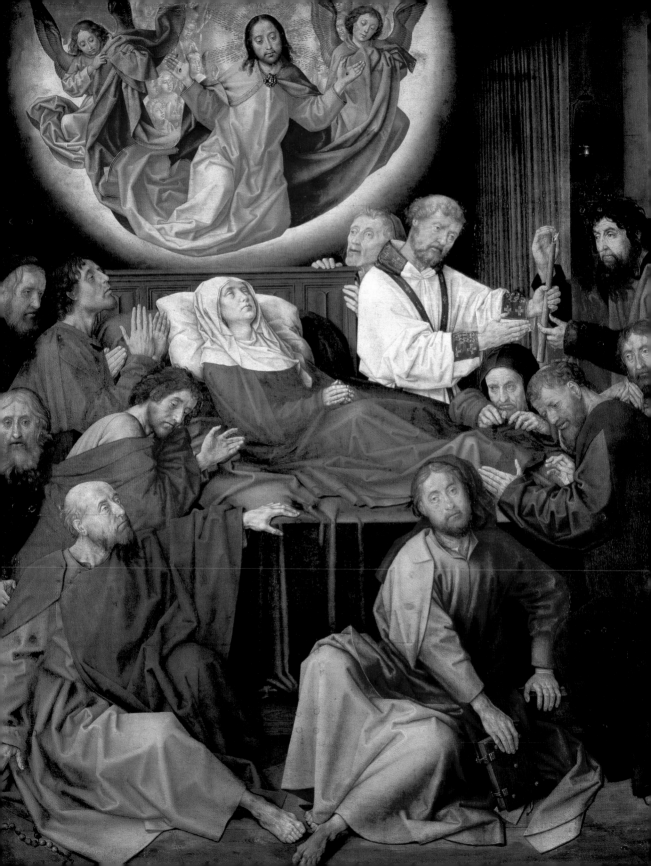